### IMAGES
*of Modern America*

# OREGON SURFING
## CENTRAL COAST

December 2024

Merry Christmas!

I hope that you enjoy these pictures of cold water surfers. They remind me of Drew!

This book was written by a wonderful couple whom I met while doing home health P.T.

Enjoy ♡

love xxoo
Aunt Donna

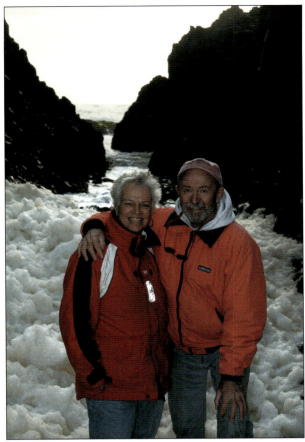

Scott Blackman began surfing at Agate Beach in 1964, when he was 26 years old. He was quickly joined by boys from the surrounding area. He helped found the Agate Beach Surf Club (ABSC). Scott soon began photographing surfing and has visually documented the Oregon coast and surfing for over five decades. Sandy Blackman was a teacher and counselor in the Lincoln County School District for 32 years. After retiring, she and Scott started an art business in 2005. Together, they have sold their art at galleries, gift shops, and craft shows. Sandy, who enjoys writing, is a successful writer and storyteller. Scott's images are sold as prints, cards, and posters and are featured in calendars, books, magazines, Web sites, and billboards. The Blackmans were inspired to tell the history of Oregon surfing after ABSC member Marty Skriver passed away in December 2007. (Photograph by Scott Blackman.)

**On the Front Cover:** Clockwise from top left:
Unidentified South Beach surfers (photograph by Scott Blackman, see page 18); Rick Baley, ABSC member (photograph by Scott Blackman, see page 75); Marty Skriver, ABSC member (photograph by Scott Blackman, see page 18); Cowabunga Longboard Classic (photograph by Scott Blackman); Bill Waterman and Steve Hall, ABSC members (courtesy of the Bill Waterman family, see page 14).

**On the Back Cover:** From left to right:
Scott Blackman, ABSC member (photograph by Jim Tucker, see page 13); 1977 Agate surfboards (photograph by Scott Blackman, see page 29); ABSC members in front of clubhouse (photograph by Scott Blackman, see page 9).

# OREGON SURFING
## CENTRAL COAST

Scott and Sandy Blackman

Copyright © 2014 by Scott and Sandy Blackman
ISBN 978-1-4671-3101-8

Published by Arcadia Publishing
Charleston, South Carolina

Printed in the United States of America

Library of Congress Control Number: 2013942810

For all general information, please contact Arcadia Publishing:
Telephone 843-853-2070
Fax 843-853-0044
E-mail sales@arcadiapublishing.com
For customer service and orders:
Toll-Free 1-888-313-2665

Visit us on the Internet at www.arcadiapublishing.com

*In memory of ABSC members David Fish and Marty Skriver and dedicated to all the Agate Beach Surf Club members—stay stoked!*

# Contents

| | | |
|---|---|---|
| Acknowledgments | | 6 |
| Introduction | | 7 |
| 1. | Pioneer Surfers | 9 |
| 2. | Surfing Contests | 43 |
| 3. | Modern Surfing | 67 |

# Acknowledgments

Compiling the history of the Agate Beach Surf Club (ABSC) became important after the deaths of members David Fish and Marty Skriver. This has become a community project with so many contributors it is difficult to single out specific people. Over the years, many have provided written stories, images, and surfing memorabilia. For those who have donated photographs, your names are listed with each image. We have listened to, recorded, laughed with, and shared countless memories of ABSC members, relatives, and friends and have enjoyed the walk down memory lane. We are grateful to all of you for sharing and being part of our lives. Thanks to the surfers who set up businesses that cater to the surfing industry in this area: Robert Rube, Al Krieger, Tom McNamara, Greg Niles, Dan Hasselschwert, Ralph Meier, Mike Jipp, Tim Henton, and Tony Gile. To the younger generation of Agate Beach neighborhood boys who followed in their older brothers' ABSC footsteps and became surfers, we especially thank Jack Skriver and Jon Holbrook, who shared personal stories with us for this book. To the second wave of surfers who migrated here and stayed when they found employment, thanks for sharing your surfing passion with us. We would like to recognize individuals and businesses who have dedicated countless hours to organizing or sponsoring a variety of surfing contests over the years: Stan and Patti Hart; Mike and Genese Mullin; Steve Swan and Stacey Maier, Rogue Brewery; Charlie Plybon and Vince Pappalardo, Surfrider Foundation; John Forse, Chinook Winds; and Tony Gile. Extra help with research, editing, and networking was done by: 'Ohana Baley, Perry Shoemake, Jack Skriver, Julie Hollen, Ollie Richardson, Mike Jipp, and Jeff Hollen. Special thanks to photographers Daniel Russo and Richard Hallman for their spectacular big-wave images. Last of all, we have been fortunate to have a wonderful editor in Jared Nelson from Arcadia Publishing. We appreciate everyone's support, be it large or small. Your amusing stories and refreshing comments have enriched our book and have helped us to historically document a small wave of surfing along the central Oregon coast.

Unless otherwise noted, all photographs were taken by Scott Blackman.

# INTRODUCTION

In the early 1960s, there was a shift in how people spent their leisure time at the beach. The book and movie *Gidget*, along with surf music, began to spread the idea of a surf culture, and Northwest teens began to wonder if it was possible to surf in Oregon's chilly ocean. Sometime during the summer of 1964, Scott Blackman, soon followed by Rick Baley and Larry Tucker, brought their surfboards to the cove at Agate Beach. Although novices, they were ready to commit a significant amount of time to surfing. Other surfing had been attempted prior to this time but only sporadically or as a novelty. During the summer of 1964, a new breed surfaced, accepting surfing as an appealing water sport. The attitude of "being a surfer," not just surfing, was a new concept.

Following in the footsteps of Blackman, Baley, and Tucker, other young boys were immediately attracted to surfing and began to surf. First it was the school-age boys of the Agate Beach neighborhood. Next, the Newport boys brought their newly acquired boards to the beach and began to surf. Within a short time, there were about 10 to 15 surfers who regularly surfed in the cove. Eventually, they organized themselves into the Agate Beach Surf Club (ABSC) in 1965. Officers were elected, a surf jacket was designed, and the group gathered regularly at a small cottage in the neighborhood that ABSC member Marion Bower's family loaned to them as a clubhouse. They came together to raise funds so that club members could travel up and down the Oregon coast, searching for new surf spots.

As members explored the length of the coast, word began to spread of other surfing communities in Seaside, later Coos Bay and Pacific City. Soon, surfing contests were held in these growing surf communities, and the ABSC became very successful. After several years, however, interest in surfing contests waned. In the late 1960s, shortboards were replacing longboards, and members of the ABSC were graduating from high school, getting jobs, going to college, or joining the service, causing the historic ABSC to disband. The era of the first pioneer surfers with longboards was coming to a close with the growing demands of adulthood.

During the 1970s, new surfers migrating to the area from California and across the state brought innovation and advancements in equipment and style. Inspired by their older ABSC brothers, young surfers who had grown up with surfing were more regularly traveling farther distances in order to surf better waves during different seasons of the year. From south to Hubbards Creek, north to Boy Scout Camp and Seaside, and eventually Hawaii, some surf trips were short visits, while others lasted for extended periods of time in which surfers would seek temporary employment within the various surfing communities. Some of the early pioneer surfers from the 1960s and 1970s who journeyed to Hawaii still live there today.

In the 1980s, a slow resurgence of surfers who were returning to the use of longboards emerged. The Cowabunga Longboard Classic began in 1982 as a friendly competition for a small gathering of surfers. Each year, the contest grew until it had gotten so large the organizers could no longer afford the cost or the time commitment required for it to continue. Other surf contests would

pop up for a year or two, but none with the staying power of the Cowabunga Longboard Classic, which lasted for 10 years.

The 1980s brought about variations to surfing in the form of sailboarding, which was popular until about the mid-1990s. Requiring less wind and equipment, kiteboarding eventually overtook sailboarding as it became more mainstream in the late 1990s. Historically, bodyboarding has been around for decades. Starting in the mid-1980s to early 1990s, it originally gained popularity in Lincoln City, where several bodyboarding contests were sponsored. Introduced in the last decade, stand-up paddleboarding is considered one of the fastest-growing water sports. Stand-up paddleboards (SUPs) allow for a wider range of athletic ability, which accounts for their increased popularity from year to year. With improved technology came the invention of personal watercrafts (PWCs) for big wave surfing, enabling surfers to reach reefs that were considered unridable in early years.

Surfing has also become a family affair, with mom, dad, and one or more children, sometimes as young as two years old, all seen surfing together. Surfing lessons are offered at most surf shops, where part of the lesson for any novice includes renting a wet suit along with the board.

Since 2005, Lincoln City has been home to the Nelscott Reef Big Wave Classic, which is now part of the professional surfers' Big Wave World Tour. With six surf shops throughout Philomath, Newport, Agate Beach, and Lincoln City servicing the surf community along the central Oregon coast, the interest in surfing does not appear to be slowing down in any way; in fact, it seems to be more mainstream than ever. Weather cams showing surf spots, cell phones connecting surfers to one another, and online information about weather conditions only seem to continuously increase the growing surf industry. Surf art graphics on boards, clothing, and paintings are also more prevalent. From its humble beginnings with the pioneer surfers, through the myriad of surf contests over the last 50 years, to the variations in surfing that can be found today, *Oregon Surfing* highlights the historic past and the ever-changing modern surf community along the central Oregon coast.

# One

# Pioneer Surfers

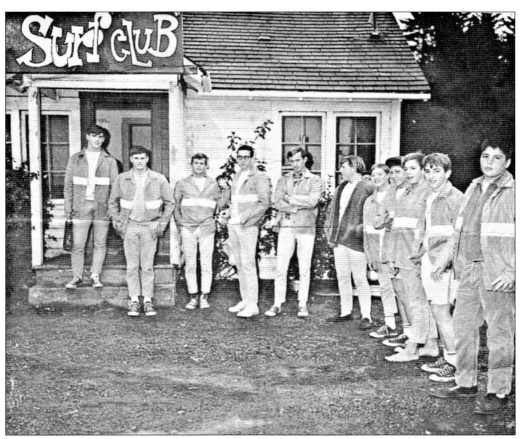

Surfing came to the central Oregon coast in the summer of 1964. By early 1965, the Agate Beach Surf Club (ABSC) was formed, with members wearing club jackets and advocating a surfing lifestyle. Gathered in front of their clubhouse around 1966 are, from left to right, Greg Hollen (vice president), Paul Kafoury, Bill Waterman, Steve Hall, Scott Blackman (treasurer/secretary), Jim Tucker, Dave Holbrook, Marion Bowers, Marty Skriver, Jeff Hollen, and Bruce McEntee. Missing members include Larry Tucker (president), Rick Baley, Wayne Bowers, David Fish, Tim Allen, Jeff Ouderkirk, Steve Baley, Jerry Holbrook, and Perry Shoemake. This chapter will feature the pioneer surfers of the 1960s and 1970s, starting with the ABSC members, other neighborhood boys who were too young to be part of the club, surfers who migrated to this area, and the surf spots they traveled to in Oregon.

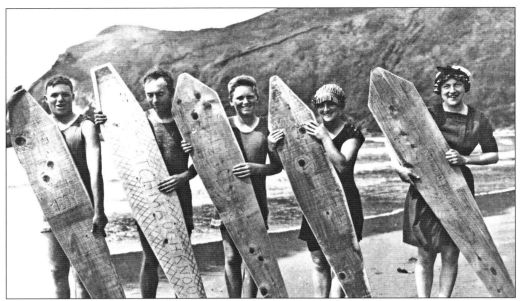

Taken in 1913 at the Agate Beach cove, this image of, from left to right, Eddie Effinger, Gilbert Mackey, Pat Effinger, Ella Baumann, and Elda Toch suggests that people may have used flat boards to play in or ride the waves at Agate Beach. This photograph from the Mackey family album was donated to the Lincoln County Historical Society and is now sold as a popular postcard along the Oregon coast. (Courtesy of Mike Jipp, Pacific Northwest Surfing Museum.)

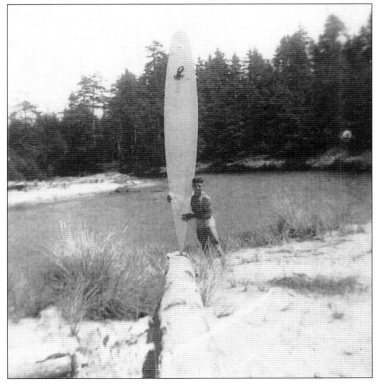

Fred Flesher poses with 12-foot, 6-inch wooden longboard near the beach at Beaver Creek, south of Newport, in 1946. Flesher constructed this board with a kit he had purchased from Popular Mechanics. The board was hollow, with no fins, but by early family accounts, Flesher was able to ride it in the ocean. These early photographs indicate that people had an interest in ocean recreation. (Courtesy of Robert Rube.)

An ideal shot of Agate Beach, affectionately known as "Mother Agate" to locals, is shown here in April 1973. After winter storms, a channel would form, allowing waves to break to the left. When it was working, this left provided a consistent wave. Agate had a sand bottom, and the left was not always there. Unfortunately, the huge amount of sand that drifted northward began to fill the cove, burying the left forever.

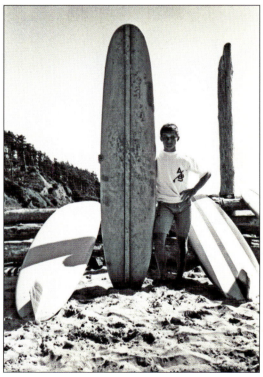

Surfing began at Agate Beach in 1964, when this was taken of Rick Baley, who reminisces about his experience: "I saw a lone surfer sitting outside on the first surfboard I'd seen at Agate Beach. As I watched, he caught a wave and rode into shallow water. I reacted as if lightning had struck our house. I ran down to the beach and introduced myself to Scott Blackman."

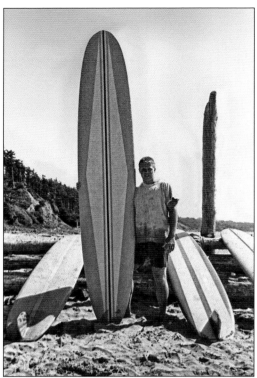

Larry Tucker stands with his board at Agate Beach during the summer of 1964. Larry Tucker, Scott Blackman, and Rick Baley built this little beach shelter as a meeting place. "We thought of the shelter as our spot and would come in for surf breaks and relax around the shelter, propping up the boards for everyone to see," Blackman remembers. "That's when we began to think of ourselves as real surfers."

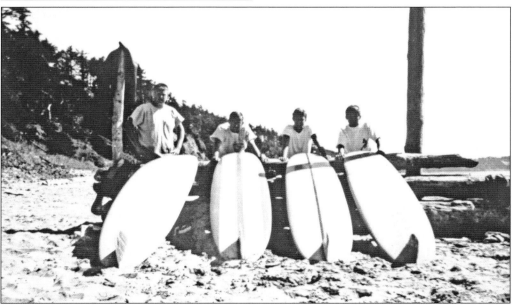

The first summer of surfing at Agate Beach in 1964 brought these four surfers together: from left to right, Larry Tucker, Scott Blackman, an unidentified California boy, and Rick Baley. No one can remember the California surfer's name. The odd thing was, although he lived close to the ocean in Southern California, he learned to surf that summer in Agate Beach. Later correspondence between the surfers revealed that he had become an active surfer when he returned home.

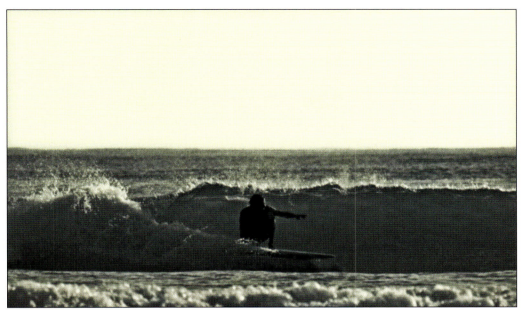

Scott Blackman catches a wave at Agate Beach around 1966. Blackman explains his initial encounter with surfing after returning from a stint in the Air Force: "It was in the air, culturally. I wasn't an athletic person. Surfing seemed like such an adventure, something people wouldn't normally do here. I wondered what it would be like to do it." Blackman, who is credited with starting surfing at Agate Beach, purchased his first board from Sears. (Photograph by Jim Tucker.)

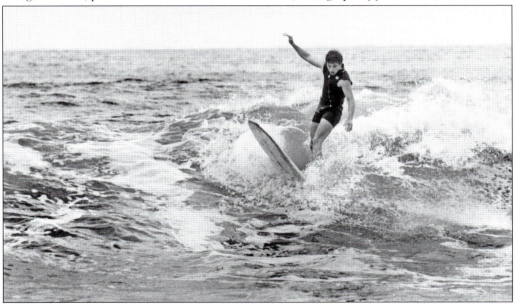

Rick Baley is seen surfing the cove at Agate Beach in the mid-1960s. "Larry Tucker came to Agate soon after Scott, and before long, we became steadfast companions, united in our devotion to wave riding. Our beach life became our center, our core, the gauge and window through which we viewed the world," Baley recalls. "To buy my first surfboard, my mother drove us 100 miles north to Seaside."

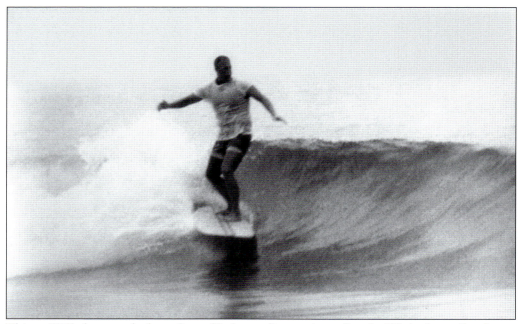

This c. 1965 photograph shows Larry Tucker surfing at Agate Beach. While Agate Beach was never known for its superb waves, it did have a protective cove formed by Yaquina Head to the north. The prevailing summer winds were partially blocked, which improved the quality of the waves. This made Agate Beach a desirable spot and a good place to learn how to surf.

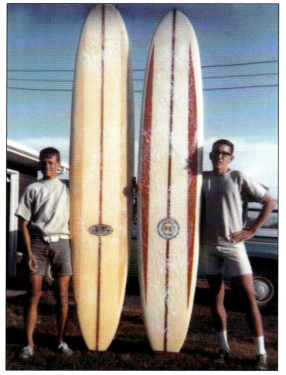

At the age of 15, both Bill Waterman (left) and Steve Hall (right) followed in the wake of Blackman, Tucker, and Baley, becoming part of the second wave of surfers at Agate Beach. The lure of surfing spread rapidly through the Agate Beach neighborhood and among the youth of Newport. "I wasn't very good at it. I wore glasses," Hall explains. "These guys accepted me and took me in. It changed my life." (Courtesy of the Bill Waterman family.)

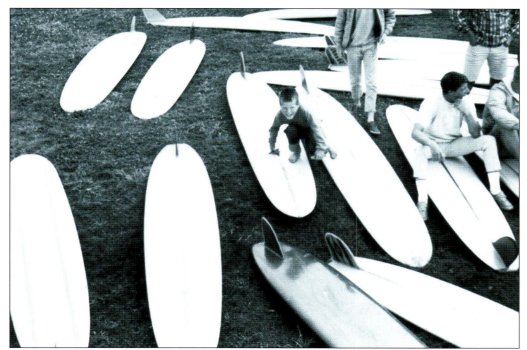

Seen on the boards in front of the Baley house, located above the cove, is Rick Baley's brother Fred in August 1965. "During the early sixties, the house and our front yard served as a gathering place for surfers from miles around," Rick recalls. "Weekends often found the parking lot jammed and the lawn covered with surfboards, old and new—few under ten feet, none less than nine feet long." (Courtesy of 'Ohana Baley.)

Agate Beach Surf Club member Marion Bowers surfs the Agate Beach reliable inside left around 1966. The Agate Beach of today is entirely different, as sand has completely buried the old break. Marion Bowers's parents, who lived on the east side of Highway 101, graciously donated a small cottage on their property to the ABSC members. It became the ABSC Surf Club House for members starting in 1965.

Considered to be the best Agate Beach surfer in the 1960s by fellow club members, Marty Skriver surfed well in waves from 2 feet to 15 feet. Skriver also had the distinction of beating out world champion Corky Carroll during a nose-riding competition at Otter Rock during the Agate Beach Surf Contest in 1967. According to his brother Jack Skriver, "Marty was only 16 at the time. This win was the most memorable for Marty."

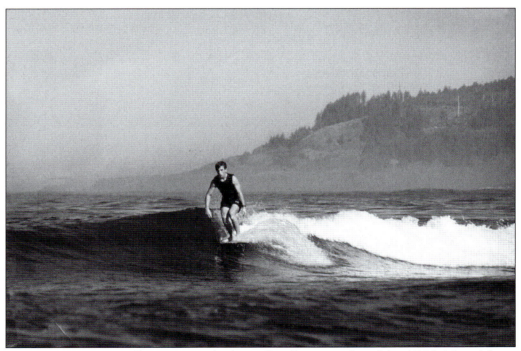

Shown here riding a small wave at Northside is Jeff Hollen, a member of the ABSC. Named for its position to the immediate north side of Yaquina Head (which also formed the cove of Agate Beach to the south), Northside was a break that club members often rode in the 1960s. When southerly winds would make Agate Beach unsurfable, there were often good surfing waves at Northside.

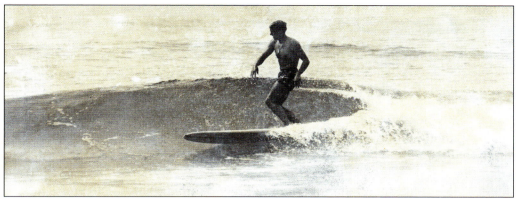

ABSC member David Fish, seen at age 16, surfs in only his trunks at the Agate Beach cove in 1966. As the club comedian and a talented artist, Fish was well liked by fellow surfers: "I respected his profound, candid assessments and easy laugh," Perry Shoemake recalls. "David was one of those old souls I aspired to emulate. He was a free thinker, and what an artist." (Courtesy of Malinda Fish Limbrunner.)

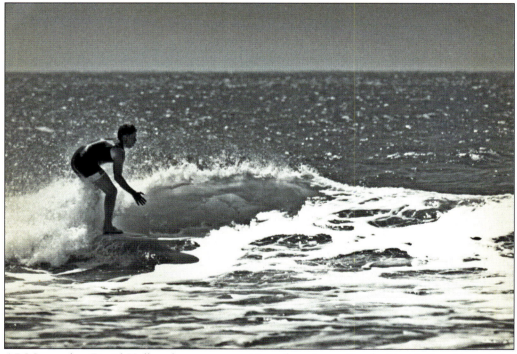

ABSC member David Holbrook, seen at age 16, surfs at Agate Beach. David, the oldest of the four Holbrook brothers, who all grew up surfing at Agate Beach, reminisces about his childhood home: "It was a great place to grow up. I had a forest on one side and a beach on the other." While in high school, David was the last ABSC president before the club disbanded.

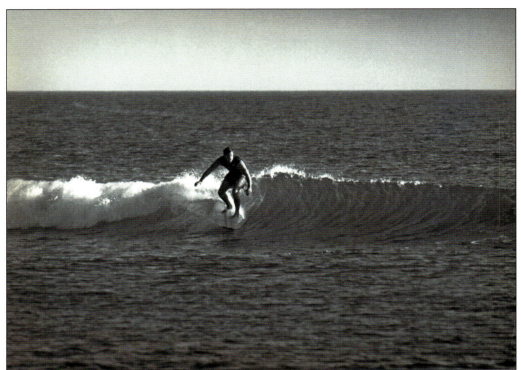

Surfing by the South Jetty in 1966 is 16-year-old Paul Kafoury, another member of the ABSC. There was no easy access to this break, as surfers had to hike three-quarters of a mile over the sand dunes while carrying their heavy longboards. This surfing spot was discovered by club members Jerry Holbrook and Tim Allen, who named it "Oranges" after the fruit they would carry for the day's adventure.

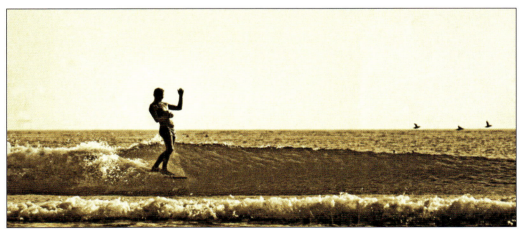

Marty Skriver had a fluid, graceful style that served him well in waves far bigger than the one pictured here. One of photographer Scott Blackman's favorite images of Skriver, this classic 1960s photograph taken at Oranges near Yaquina Bay's South Jetty was used on posters and shirts to promote the 1988 Cowabunga Longboard Classic at Otter Rock.

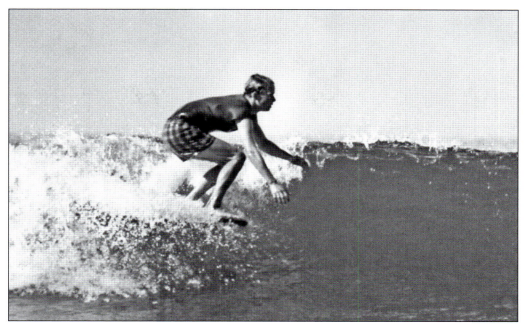

Bill Waterman, shown here surfing at Otter Rock around 1966, describes his lifelong passion for the sport: "The ocean taught me the most respect for nature. Once you're in, it's like being a gang member. Once you do it, it's, like, instilled in you. You're in for life." Waterman became a well-known, accomplished surfer, so much so that Blackman's photograph of him in a similar pose was featured in the March 1966 issue of *Surfer* magazine.

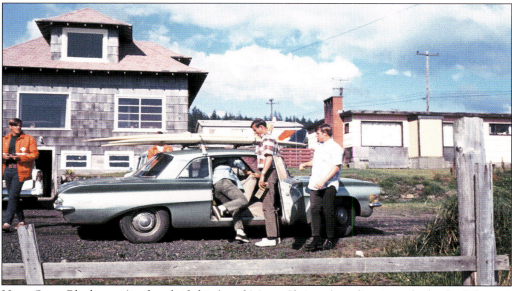

Here, Scott Blackman (in the plaid shirt) and Marty Skriver (crawling into the back of the car) are getting into the Baley family car, driven by Rick Baley. Blackman recalls that Marty, Rick, and he "were starting off on a 16-hour drive into the 'promised land' of Southern California surfing." This was the first surfing trip to Southern California for any club members. Unfortunately, Paul Kafoury (in the club jacket) and Jim Tucker (on the right) were unable to go.

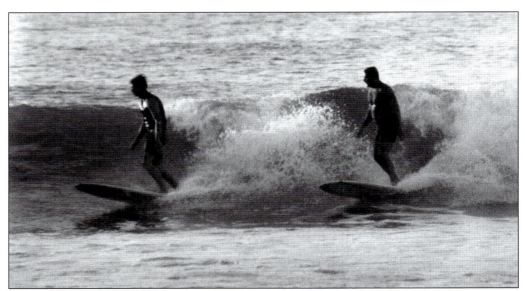

Scott Blackman recalls the highlights of their first trip to Southern California, one of which was the consistently good surf: "We surfed Malibu under good conditions, and this [photograph] shows Rick Baley [left] dropping in on J.J. Moon, touted by *Surfer* magazine as one of the best in the world. Moon's status was an acknowledged hoax by the magazine, and we were excited to have this image of Rick and J.J. together."

Note the prices in this photograph taken by Scott Blackman while on the road through Ventura, California, in September 1966: "I took this shot of Marty Skriver and Rick Baley. We weren't really looking for fine dining on our surf trips. I think we all probably preferred junk food, anyway, and had no extra money. We slept in the car or in sleeping bags near it. The surf was good, and the trip a big success."

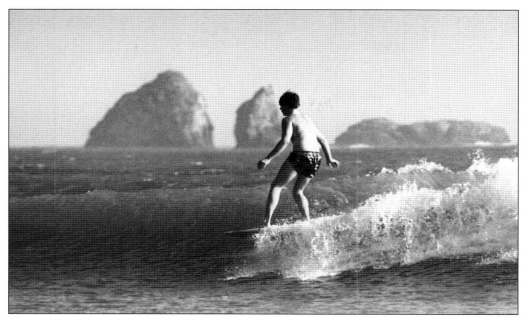

Shown here at Hubbards Creek near Port Orford, Bruce McEntee started surfing in 1964, when he was 12 years old, and later became a member of the ABSC. In the beginning, the Agate Beach surfers did not wear full-length wet suits; they used "short johns," which was an inadequate alternative for Oregon's cold water, as their arms and legs were exposed. McEntee was one of the brave few who would occasionally surf without a wet suit.

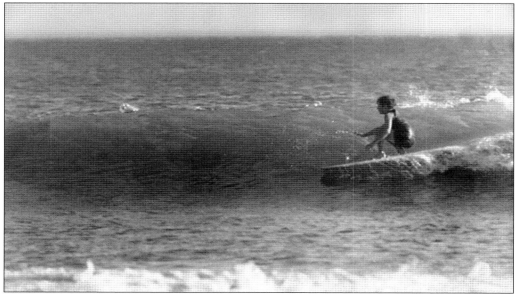

Jack Skriver, Marty's younger brother, is seen here at age 11 at Hubbards Creek, near Port Orford, in 1967. He would come along on some of the club's surf trips. Skriver details his first wet suit as follows: "My first wet suit came from Marion Bowers, who made it out of small wet suit scraps. It resembled a quilt and was too small for Marion. I bought it for 50 cents. It was hilarious, and it always got laughs."

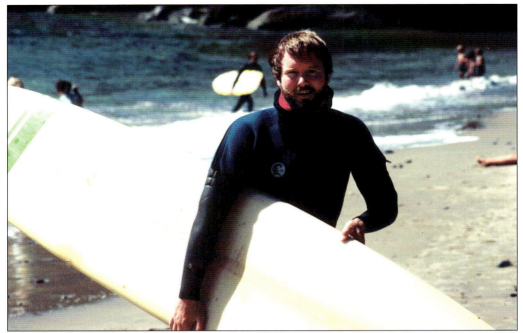

Jeff Ouderkirk, an ABSC member, describes surfing as "pitting yourself against nature—competition, but not against others." He goes on to say, "It was the sixties and a cultural lifestyle—fun to do." After graduating from college, Ouderkirk returned to Newport and, together with fellow club member Jeff Hollen, started a law practice, which continues today.

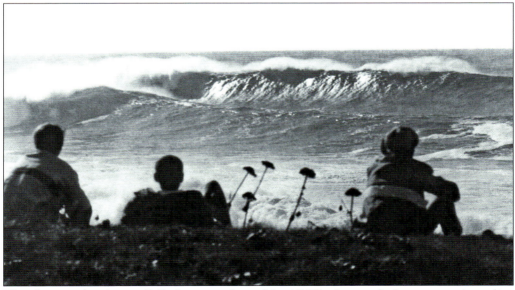

This photograph, taken in 1968, shows members of the ABSC taking in the huge waves. According to Jim Tucker, "Five of us Agate Beach members watched the storm waves south of Depoe Bay while Scott photographed. They were the biggest Oregon waves we had ever seen and far too big for us to surf. We were really stoked when Blackman's photo of Marty Skriver, Marion Bowers, and Jeff Hollen got into *Surfing* magazine of July/August in 1968."

Fred Baley and Jack Skriver, both 12 in 1968, are "stick-putting," which was a favorite activity among the younger Agate Beach boys, as explained by Skriver: "We took pieces of driftwood shaped like tiny surfboards, attempting to get a good ride mimicking a surfer. This was accompanied by loud oohs and aahs as our 'putts' either performed well and got tubed or faltered and got sucked over the falls."

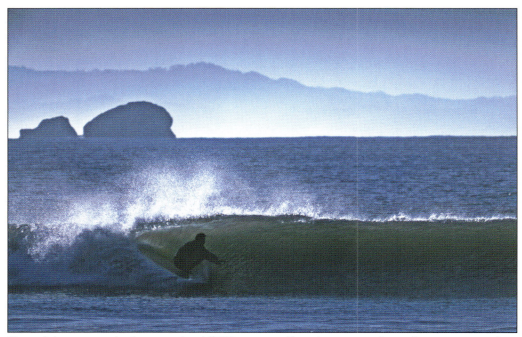

One of the reasons for forming the ABSC was to collect dues to pay for surfing trips to explore other parts of the Oregon coast. One of the club's favorite discoveries was the area around Port Orford and Hubbards Creek. This image shows Marty Skriver surfing at Battle Rock, near Port Orford, in December 1969.

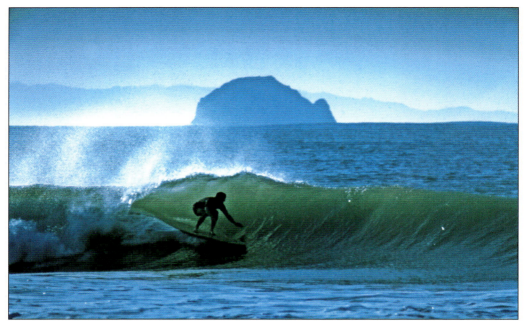

Here, Jeff Hollen surfs on a great morning at Battle Rock in December 1969, but not every day was great, as Blackman recalls: "The three-hour drive to Port Orford often resulted in poor surf and disappointment. This time we were rewarded with excellent surf." Battle Rock is within the city limits of the small coastal town of Port Orford.

In early November 1969, during a period of time, a clean swell came to Agate Beach. All the surfers of that era remember it to this day: "The left was pumping, and the channel had been cleaned out by the winter storms," Blackman explains. "This was about as good as Agate could get." Now gone, this break is covered by huge amounts of sand that washed into the cove.

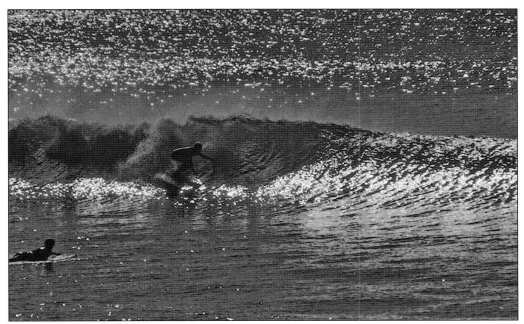

Local Otter Rock surfer Tom Hastings takes off from the crest at Agate Beach in November 1969, near the tail end of peak surf season. Good conditions started in September and ran through October and November. Most of the old-timers still remember the great waves and surfing during the fall of 1969.

David Fish is carrying a radical shortboard at Agate Beach in 1969. After surfing longboards for five years, Fish eventually joined the "shortboard revolution," which swept through Oregon starting in 1967–1968. Before shortboards arrived at Agate Beach, some of the club members would cut a foot or more off their boards, reshaping and reglassing them. These boards worked poorly, however, and were soon replaced with professional shortboards.

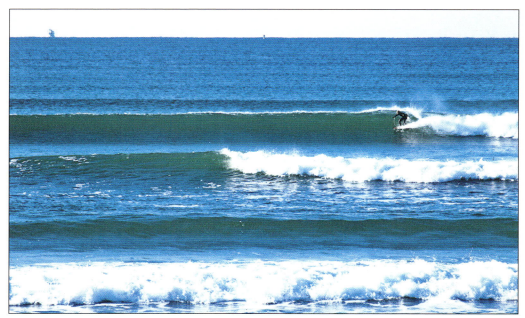

Here, Jerry Holbrook is surfing at South Beach in 1972. A member of the ABSC, Jerry was the second oldest of the four Holbrook brothers who grew up in the Agate Beach neighborhood. According to Jerry, surfing totally changed his life: "I would have had a different life if I hadn't become a surfer."

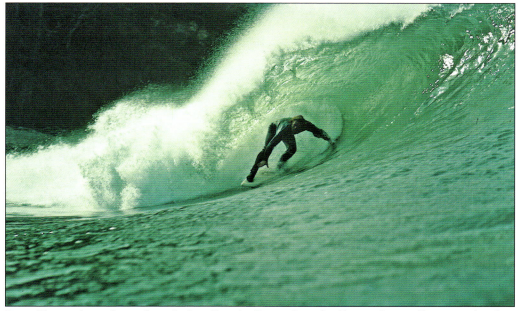

Perry Shoemake is shown here "tubing" at the Point, Seaside. Shoemake recalls getting his first surfboard in 1966, when he was 15 years old: "It was a nine-foot-six board, weighing 60 pounds, and made by Ron George in shop class." Shoemake was the last to join the ABSC, as he lived in California and Toledo during high school. He eventually moved to Astoria to attend college, often hitchhiking to Seaside to surf the Point. (Photograph by Tim Mack.)

Nice small waves and an empty lineup are seen here at Otter Rock, located about eight miles north of Newport. Otter Rock was one of several places on the central coast that attracted surfers. Like Agate Beach, its protective cove created waves that were small enough for beginners, making it a destination for novice surfers from around the state in the 1960s.

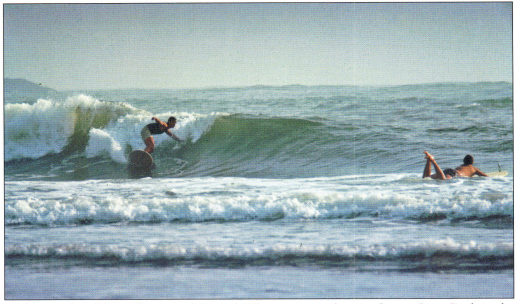

ABSC members Marty Skriver and Bruce McEntee are seen here surfing at Otter Rock in the late 1960s. Both avid surfers, Skriver and McEntee do not require much protection from the cold waters to pursue their passion: "I always know when it is time to go surfing," McEntee says, "and I tell my friends I have to get 'baptized.' I feel refreshed, revitalized, like I've been baptized. To surf is to commune with nature."

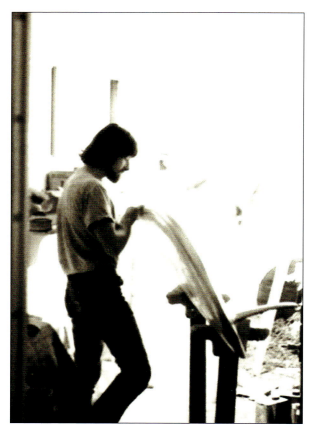

John Kelsey, a native of Riddle, Oregon, moved to Southern California as a teen. John remembers, "I was inspired to make boards after seeing a friend make one in shop class at Beuna Park High School." Leaving California and on an exploration of the Oregon coast, he and Don Brown arrived in Agate Beach. John opened his shop in Agate Beach in 1968 and made boards for the ABSC members.

Marty Skriver watches as Jim Tucker finishes a board in front of John Kelsey's shop in October 1970. In 1968, Tucker learned how to glass boards from Don Brown and how to shape boards from John Kelsey. "I started making boards for myself and, eventually, for the local guys like Marion Bowers and Stevie Skriver," Tucker remembers. "John Kelsey was in California during the winter, and I began making boards when he left."

Known primarily for his board-shaping skills, John Kelsey is seen here at Moolack Beach in early 1970 in one of the few photographs taken of him coming in from surfing. Moolack Beach, located midway between Agate Beach and Otter Rock, was surfed only occasionally, as it was vulnerable to any winds that came up. Even when the winds were calm, the sandbar bottom seldom produced great waves.

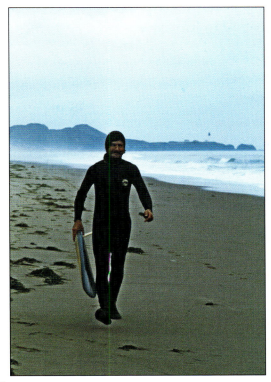

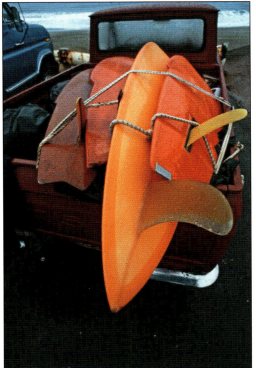

A spectrum of board shapes, colors, and designs common in the 1970s is displayed in this pickup truck at Gleneden Beach in September 1977. The old beat-up pickup truck was also common. For the most part, young surfers lacked money for better transportation. The four surfers who would soon unload the boards to go surfing were Dana Taylor, Perry Shoemake, and brothers Jerry and Jon Holbrook.

With his board and wet suit at the ready, Jerry Holbrook checks the surf at Moolack Beach in November 1971, contemplating whether to go surfing. Without technology or swell reports, surfers would have to rely on their observations. His brother Jon describes Jerry as "one of the best surfers in Oregon in the 1970s."

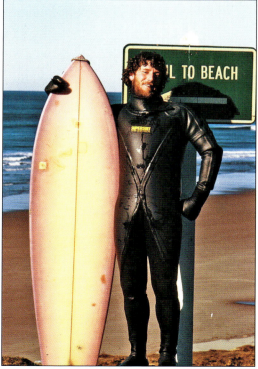

Mark Hunter is shown on Moolack Beach in the early 1970s. Surfers Mark Hunter and Mike Haycraft were involved in an exciting rescue of six people who were caught in the riptide at Beverly Beach. There were actually two separate rescues in one day, only an hour apart. Able to save everyone by using their boards, both surfers were recognized by the Newport Police Department for their heroism.

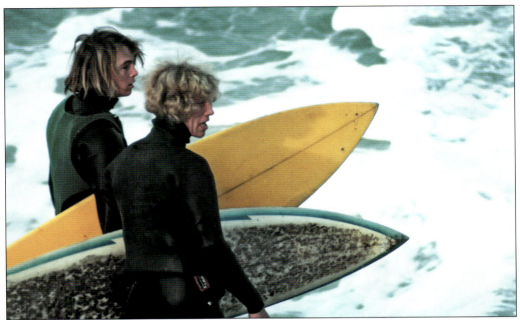

Steve Skriver (left) and Jim Smith (right) prepare to enter the water at Boiler Bay in the mid-1970s. Boiler Bay was one of the first reef breaks to be ridden in the central coast area. As Steve's older brother, Jack Skriver, recalls, "Steve was pretty much the king of Boiler Bay for a period of time. Steve started surfing Boiler when he was around 13 years old, in 1970."

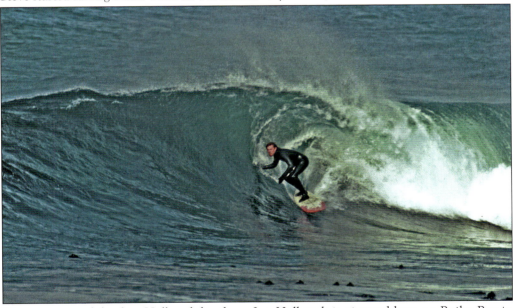

The youngest of the four Holbrook brothers, Jon Holbrook is pictured here on Boiler Bay in the mid-1970s. According to Jon, "Boiler Bay was surfed mostly by me, Jack and Steve Skriver, and a few others in the early days. Big drop but short wave, one of the only south wind spots in Lincoln County, so often times, the only place to surf in the winter. I surfed it many a day like this one."

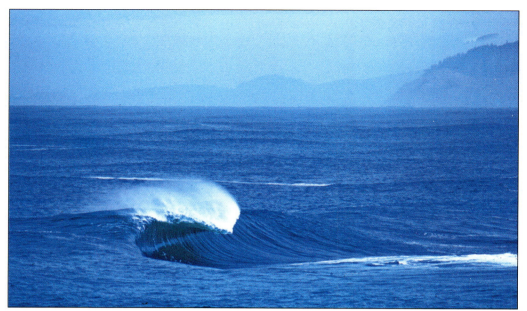

Scott's Reef was named after Scott Blackman, who first discovered it in the early 1970s. As a photographer, Blackman said the reef caught his eye because of the way it broke over the shallow reef. He started encouraging other surfers to keep an eye on it. As a result, surfers eventually began referring to it as Scott's Reef. Though Blackman was never able to surf the reef bearing his name, today big wave surfing is possible, even at Scott's Reef.

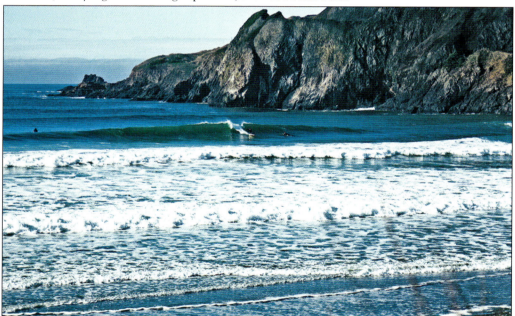

This is a good shot of the cove at Agate Beach when the left was working. Mostly showing up in the fall and winter, this left was thought of as the predominant wave in the 1960s and 1970s. Surfers looked forward to riding it, a feat made possible by the channel that formed after a few winter storms had washed out the sand.

Here, two locals are contemplating a "go-out" at Agate Beach in the 1970s. Agate Beach no longer appears this way, however. As Jack Skriver recalls, "In the seventies, there were three or four little creeks the first quarter mile and no sand dunes at all. Today, Big Creek flows along the bank from Newport, consuming all the small creeks and exits into the cove at Agate; and there are three foot sand dunes in some places."

The third of the Holbrook brothers, Tim Holbrook is seen launching into a sizeable left at Agate Beach in 1976. This wave was about as big as Agate could hold.

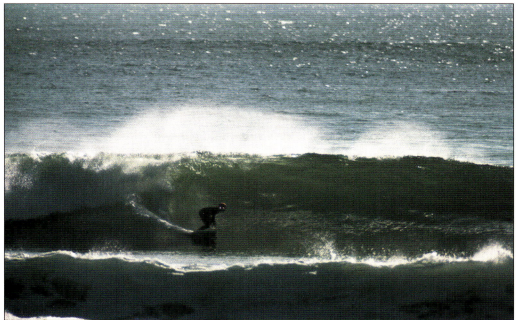

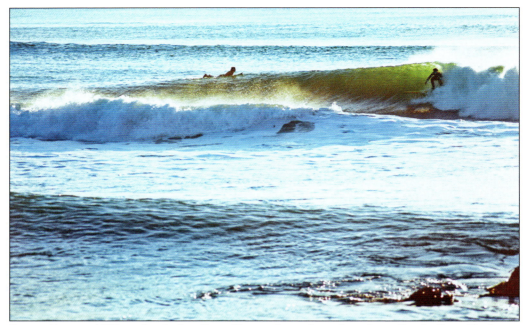

Pictured here in 1975 is either Jack or Steve Skriver during low tide at Agate Beach. Scott Blackman often photographed Steve Skriver riding deep within the tube of waves. Now, 35 years later, it is hard to distinguish between Steve and Jack Skriver, with their similar styles and close ages. Thus, it is up to the reader to decide which of the Skriver brothers is locked in.

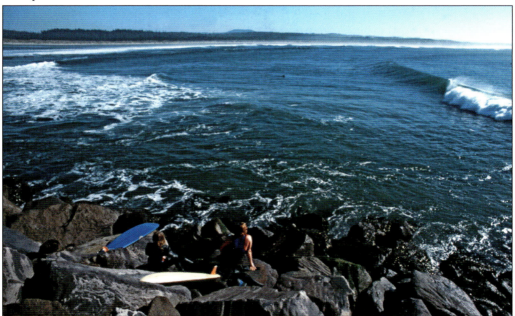

In the late 1970s, a new wave developed adjacent to the South Jetty. This wave provided some excellent opportunities for good surfing over several months. Due to the increased movement of sand, some surf spots can change from time to time, sometimes disappearing completely, as at this spot and the cove of Agate Beach.

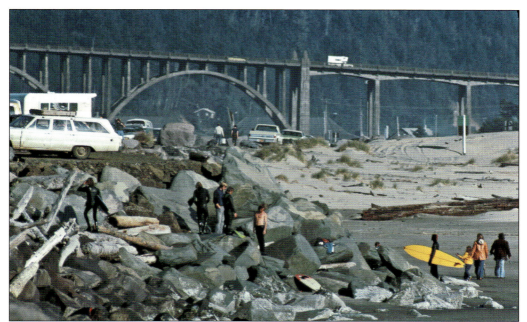

While they lasted, the waves at the South Jetty drew crowds of local surfers in the 1970s. When word got around, surfers from other areas soon arrived. This view looking eastward along the South Jetty includes the Yaquina Bay Bridge. The surfers in wet suits gathered near the center of the photograph are, from left to right, Jim Smith, Steve Skriver, and Jon Holbrook.

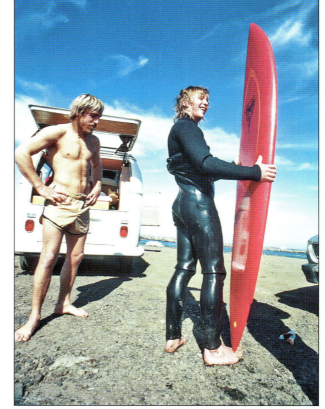

Shown in his wet suit on the South Jetty, Steve Skriver holds his brand-new board, just handed to him moments before this photograph was taken in the mid-1970s. Looking on is Bob Hollen, the youngest of the three Hollen brothers who grew up in Agate Beach. Both Skriver and Hollen were too young to be members of the ABSC in the 1960s.

Steve Skriver is seen here carrying his new red surfboard in February 1977. Tired, Skriver ends his day with the added effort of trudging across the soft sand beside the South Jetty. According to his brother Jack, "Steve would wear his wetsuits to the bitter end. He'd duct tape the bottom of his legs to seal up the booties. Booties that filled with water were obnoxious and to be avoided."

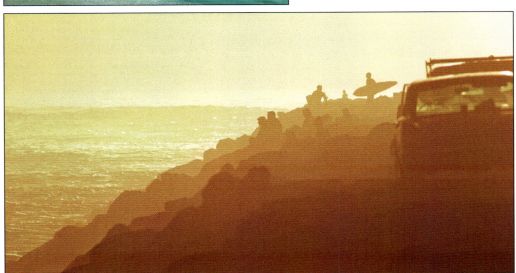

Shown here in the late afternoon in February 1977, the South Jetty was shared with a host of fishermen, walkers, tourists, and surfers, causing it to become quite crowded at times. In those days, driving on the South Jetty was permitted, but parking was often scarce. Vehicle access to the South Jetty has since been closed in the last couple of years.

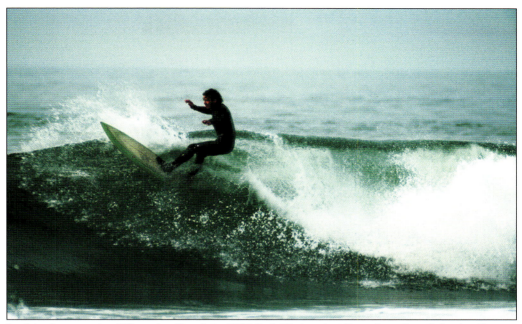

In this photograph of Gleneden Beach in 1976, Jack Skriver is riding a board made by Art Spence of Seaside. Skriver identifies Gleneden as one of his favorite places to surf: "There were always powerful waves there due to formation of sand. Gleneden was a wide-open beach and needed favorable wind conditions." The Gleneden sandbars form in a unique manner, and channels can be deeper and wider than normal.

Watching the surf at Manzanita in October 1976 are, from front to back, Agate Beach surfers Jim Smith, Steve Skriver, and Jerry Holbrook. They are checking out the break at the base of Neahkahnie Mountain on the north coast. Jerry Holbrook was a member of the ABSC in the 1960s, while Jim Smith and Steve Skriver started surfing at Agate Beach in the late 1960s and early 1970s.

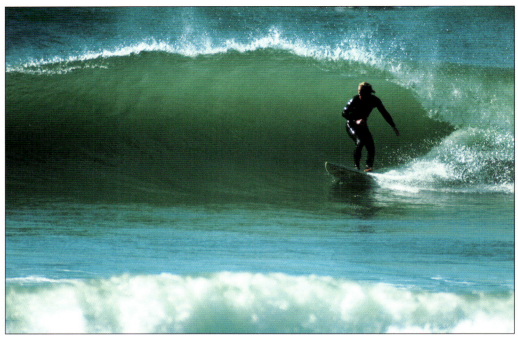

Jim Smith, who passed away in July 2013, is seen at Manzanita in October 1976. Minutes after checking out the Manzanita surf, Jim Smith was in the water and backing into this hollow right. As Scott Blackman recalls, "Jim would often remark that this photo of him was one of his favorites over the years. I remember the trip to Manzanita to photograph Jim, Steve, and Jerry."

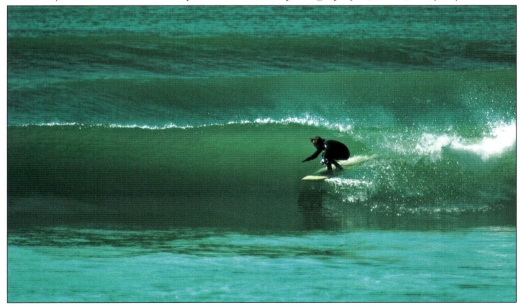

Steve Skriver became an excellent surfer, traveling up and down the coast of Oregon, including this spot at Manzanita in 1976. Other favorite spots were Seaside and eventually Hawaii, where he resides today. According to his brother Jack, "Steve was more of a soul surfer who would flow with the wave and ride in the curl. If there was a tube on the wave, Steve was sure to be in it."

Here are two Agate Beach surfers at Boy Scout Camp in September 1976. Cape Lookout is easy to find on any map of the Oregon coast, as the cape juts out about three miles into the ocean. The beach shoreline is uninhabited. In the 1970s, access to this surf spot, which got its name from Camp Meriwether, a nearby Boy Scout camp, was difficult; surfers had to sneak through the camp's private property to reach the surf.

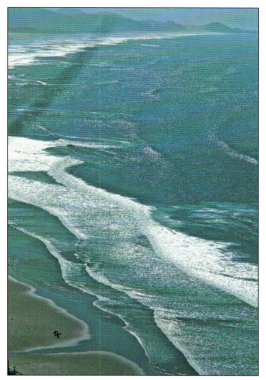

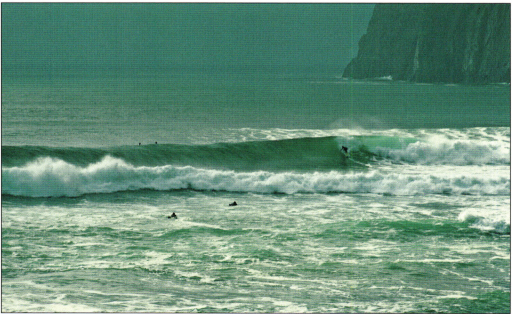

This is a shot of a group of Agate Beach surfers at Boy Scout Camp in September 1976. Boy Scout Camp had a reputation for some of the finest waves on the Oregon coast. Although this day had good size, it was not one of the fabled days. If surfers did not sneak through the camp, they would descend a long, steep hill to the beach, but climbing out at the end of the day was difficult.

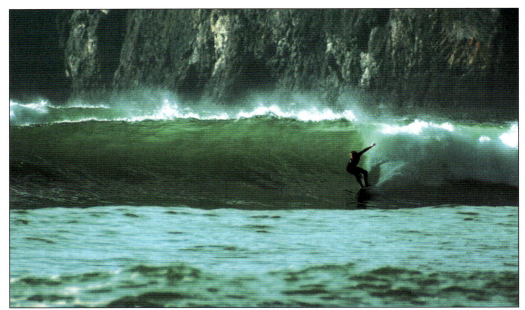

Shown here at Boy Scout Camp in September 1976, Tim Holbrook takes off backside. His brother Jon recalls, "When we first discovered Boy Scout Camp in the early seventies, it instantly became our surfing spiritual center. Just standing on the beach and looking out at the head was awe inspiring, not to mention the quality of the waves were a step above anything we had in Lincoln County."

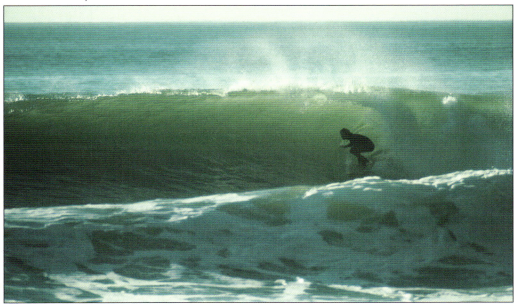

Jon Holbrook, seen here at Boy Scout Camp in September 1976, reminisces about their trip with his usual sense of humor: "We quickly began bypassing everything else and, conditions permitting, would make a beeline north. Something about the ambiance is indescribable. We would camp for days on the small ledge directly above the lineup and be lost to the world. Some of the memorable times included moonlight surfing, seeing Bigfoot, and surfing naked."

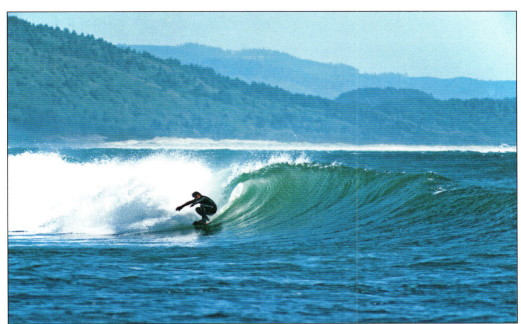

In this photograph, Jack Skriver is working his way through the left at Boy Scout Camp in September 1976. This left would sometimes break on the south side of the channel, as Jack recalls: "The left broke a lot when the swell had too much north for the 'rights' in the cove. Sometimes it had a monstrous rip. Some days, it was difficult to ride the left because the rip was so strong."

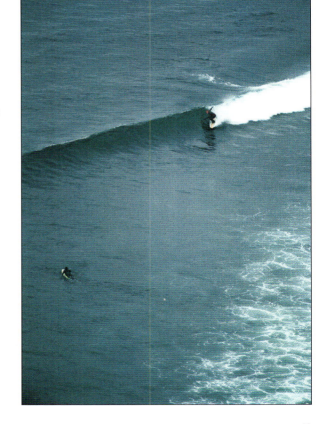

From the vantage point of the steep trail above the camp, Jerry Holbrook is seen surfing in September 1976 on the more preferred right for which Boy Scout Camp was known. Holbrook surfed in many locations, including Hawaii, where he lives today: "Surfing was all about traveling. Surfing was the best thing ever."

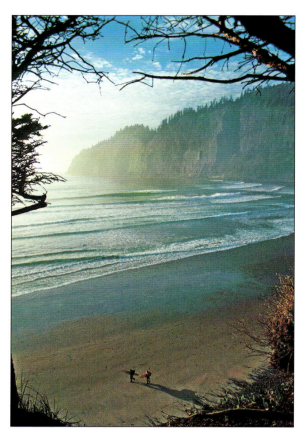

The two Holbrook brothers—Jon and Tim—are seen at the end of the day at Boy Scout Camp in September 1976. According to Jon, it was "just another day, nobody else around, and pure magic surrounded us in every way. Scott sold this photo to *SURF* magazine and they marketed it as a poster. I think I bought the last one."

Portlander Tim Mack learned to surf in Hawaii with his father, Forbes Mack, during family vacations and later became an accomplished photographer of surfing in Oregon and Hawaii. Seen in his boat at Newport Harbor in September 1977, Mack is holding up the November 1977 issue of *Surfer* magazine that featured his photograph of a surfer at Honolua Bay, Hawaii, on the cover.

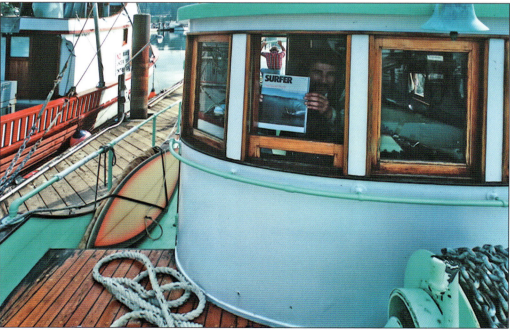

# Two

# SURFING CONTESTS

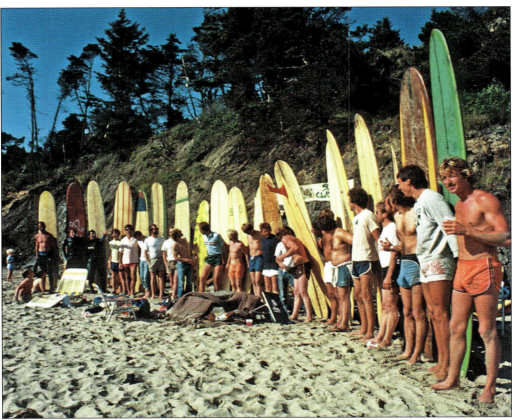

Surfing contests began on the central Oregon coast in August 1965 at Agate Beach. They were well attended even though they were loosely run and organized by a few Agate Beach surfers. There were no event T-shirts, posters, or newspaper coverage. In 1966 and 1967, the ABSC members officially hosted surf contests at Agate Beach and Otter Rock. A desire to emulate the surfing culture of California, combined with the drive of young males to compete against each other, fueled the desire for these events. Contests also helped to bring the various coastal surfing communities together. This image depicts the second Cowabunga Longboard Classic, held in Otter Rock in the summer of 1983. Surf contests have waxed and waned for years, mostly due to the sporadic weather conditions and the inability to predict surfable weather; trying to find sponsors to finance the contests is another issue. Current competitions are Otter Rock-n-Roll Surf Contest for youth, sponsored by the Surfrider Foundation, and the Nelscott Reef contest, part of the professional surfers' Big Wave World Tour.

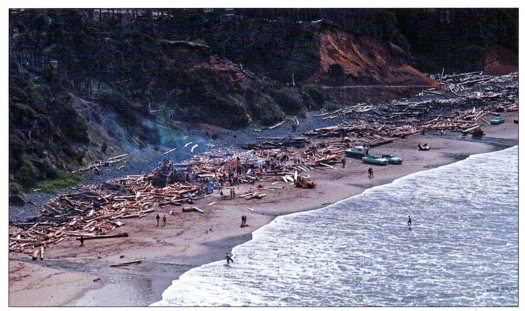

The first surf contest along the central Oregon coast was held at Agate Beach around August 1965. Dirftwood was abundant, and cars could legally drive at Agate Beach at the time. No posters or newspaper articles exist, making it difficult to reconstruct this contest. Some historic images from various sources show the contest took place in August 1965. A few ABSC members sponsored the event, since the club was in its infancy. (Photograph by Tim Mack.)

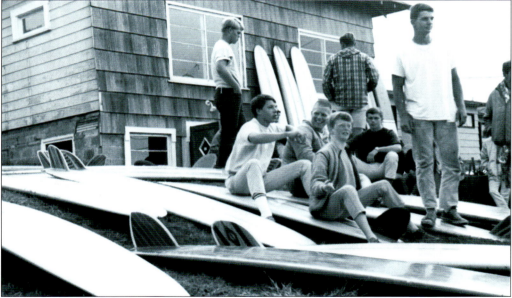

The Baley house, above the Agate Beach cove, was always a gathering spot for ABSC members and other surfers, especially during the Agate Beach Surf Contest in August 1965. Pictured here is Larry Tucker, sitting on his board in the center with a big grin on his face, and next to him is Rick Baley in the dark T-shirt. Longboards used in the 1960s often had decorative wooden fins, as seen here. (Courtesy of 'Ohana Baley.)

Larry Tucker, ABSC president, receives the first-place trophy at the Agate Beach Surf Club contest in August 1965. Larry recalls, "some of us decided to sponsor a contest after attending Coos Bay's Surf Escapades in June 1965. Because I was ABSC president I added up the judges' scores and found out I had won. Today that wouldn't be allowed but back then we were just learning how to put on a surf contest."

Portland surfer Sam Beck placed second behind Larry Tucker in the first Agate Beach Surf Contest in August 1965. Beck was an advanced surfer for the day. Originally from California, Beck had the advantage of learning how to surf on California waves. He left the Northwest in the late 1960s, but his current whereabouts are unknown.

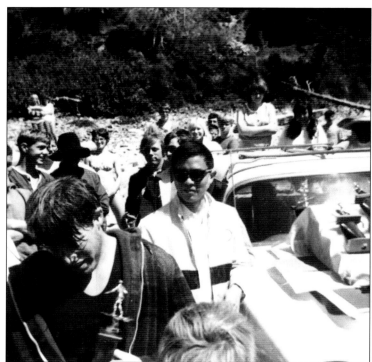

ABSC member Jim Tucker, younger brother of Larry Tucker, receives a trophy from contest judge Jim Sagawa (seen in dark glasses) at the Agate Beach Surf Contest in August 1965. Originally from Hawaii, Sagawa was well known in Oregon surfing. Though he attended Oregon Health & Science University dental school, he ended up making his own brand of surfboards. His SAG boards, an abbreviation of his last name, were a status symbol to some surfers. (Courtesy of Malinda Fish Limbrunner.)

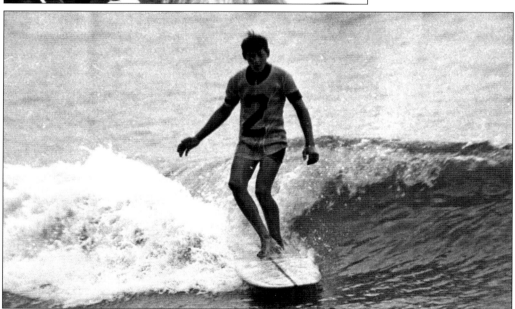

Here, Marion Bowers is competing in the Far North Coast Surfing Championships, held at Shelter Cove on Memorial Day weekend in 1966. At the time, Arnold Sharp was the coordinator and president of the North Swell Surf Association (NSSA) of Eureka. "We had concerns about doing well against California surfers, but we brought home five out of the fifteen trophies," Scott Blackman recalls. "As members, we always refer to this as the Shelter Cove Contest." (Courtesy of Mary Ann Machi, NSSA.)

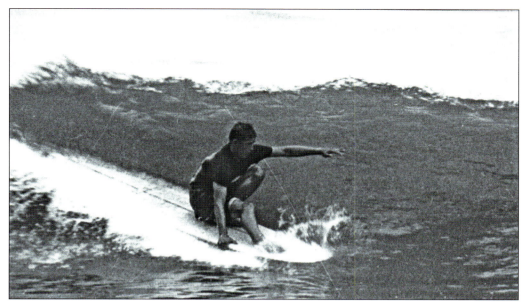

Marty Skriver is seen competing in the junior men's final at Shelter Cove, which he won with rides like this. According to Scott Blackman, "It was a long drive to reach this contest in an isolated stretch of California's coast. The ABSC members slept in sleeping bags, outside by their cars, for the weekend. We returned to Oregon with increased respect for Marty's surfing. He took first place against stiff competition." (Courtesy of Mary Ann Machi, NSSA.)

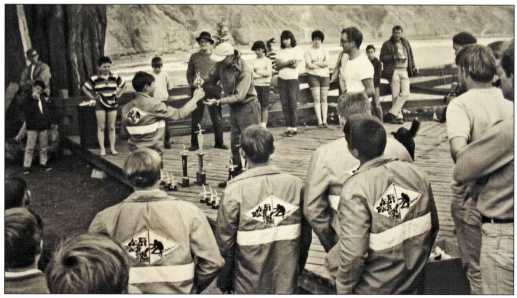

John Heath "Doc" Ball presents Marion Bowers with one of his two trophies at the Shelter Cove contest in Northern California in May 1966. Ball was very influential in the growth of surfing in California, especially between the 1930s and 1950s. Along with being a surfer, he is considered the first truly dedicated surf photographer. Seen here wearing their club jackets are, from left to right, ABSC members Dave Holbrook, Marty Skriver, Larry Tucker (partially hidden), and Bruce McEntee. (Courtesy of Mary Ann Machi, NSSA.)

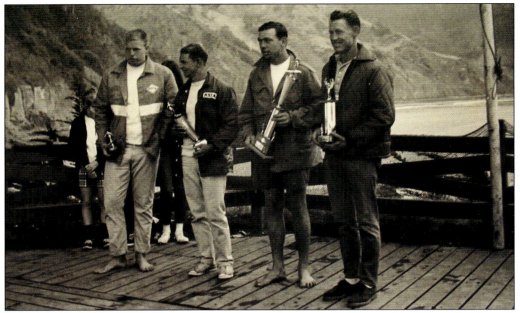

Larry Tucker, ABSC president, was a finalist of the senior division at Northern California's Shelter Cove Contest on Memorial Day weekend in 1966. In the early days, Tucker did well in the senior division of surf contests at Agate Beach, Seaside, and Shelter Cove. He then attended college before joining the Navy to serve on nuclear submarines. Tucker currently lives in Hawaii. (Courtesy of Mary Ann Machi, NSSA.)

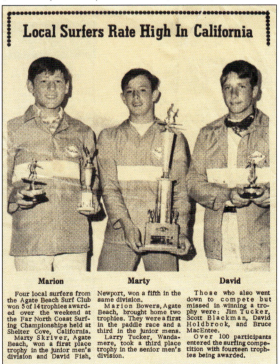

The first and only time ABSC members competed in a Northern California surf contest was Memorial Day weekend of 1966. Those who placed in the contest include Marion Bowers, first in the paddle out and third in the junior men's division; Marty Skriver, first in the junior men's division; and David Fish, fifth in the junior men's division. All three members were high school students at the time. Larry Tucker (not pictured) also received a trophy. (Courtesy of *News Times*.)

The 1966 ABSC Contest poster, designed by Scott Blackman, features member Jeff Hollen. Blackman comments, "the 1965 Agate Beach contest was put on by some of us, but 1966 was the first year the ABSC officially sponsored one. Lacking a year date, sketchy memories from ABSC members 45 years later leaves room for interpretation." ABSC members organized contests for several years, hoping for good surf conditions and to meet surfers from other areas. (Courtesy of Knox Swanson.)

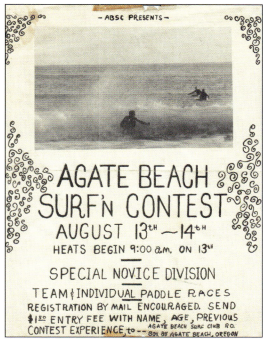

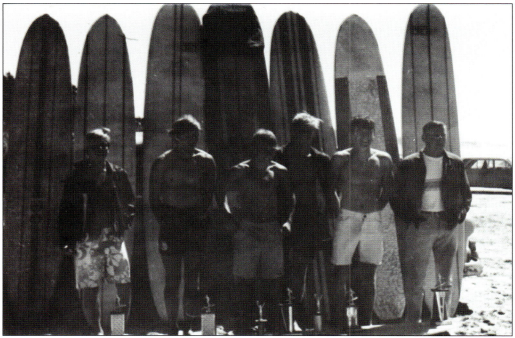

In 1966, this group of Washington surfers swept the Agate Beach Surf Contest. From left to right are Ron Ashelman, Dan Norton, Steve Lewis, Brian Jett, and Darrell Woods, all members of Renton's Sun Surf Club, and Peter de Turk, who was in the military and stationed in Washington. De Turk recalls, "I won the Open division in 1966. This photo of me and the Washington crew were all finalists but not necessarily first place finishers." (Courtesy of Peter de Turk.)

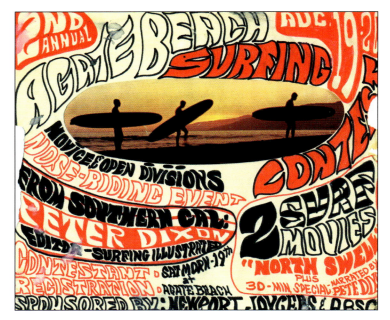

The year is missing, but it's believed this poster advertises the 1967 ABSC contest. This would have been the second contest that ABSC members sponsored, but it was the third contest to be held by Agate Beach surfers. Part of the contest was held at Otter Rock. The editor of *Surfing Illustrated* magazine, Peter Dixon, arrived with two surf movies. Scott Blackman designed the poster, which reflects the design styles prominent in the mid-1960s.

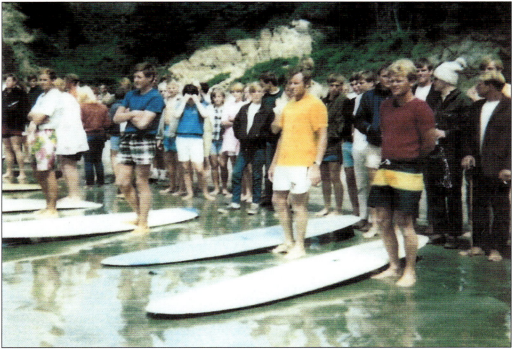

The 1967 Agate Beach Surf Contest got a boost when world champion Corky Carroll became a contestant. Scott Blackman remembers, "I received a phone call from Corky asking if he could compete. I was astonished that Corky would want to be in our little contest." The four competitors standing by their boards at Otter Rock are, from left to right, ABSC members Tim Allen (white shirt) and Marion Bowers; Corky Carrol (white trunks), and Seaside's Sandy Barrett. (Courtesy of Sandy Barrett.)

In the summer of 1967, Corky Carroll arrived at the Agate Beach Surf Contest with his wife, Cheryl, who was very sweet and well liked by everyone. Referred to as "Miss Bitchin," Cheryl's nickname was a compliment to her personality and looks. The term "bitchin'," implying that something was exceptionally good, was used as popular 1960s slang in the surfing community.

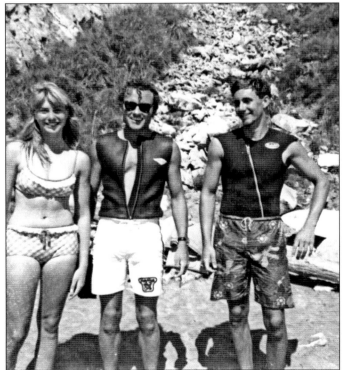

Linda Allen and her brother, ABSC member Tim Allen, flank Corky Carroll at the Agate Beach Surf Contest held at Otter Rock in August 1967. Linda was one of the only local girls to surf regularly as a teen: "I caught my first wave at age 12; I knew I was in *love!*" She competed against males in three surf contests in 1966 and 1967, receiving the second-place trophy at Pacific City. (Courtesy of Linda Allen Hearing.)

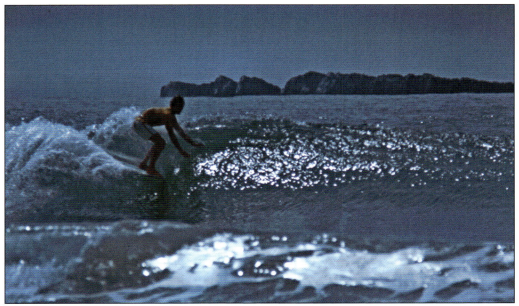

This photograph of Corky Carrol surfing at Otter Rock during the 1967 Agate Beach Surf Contest was taken at the nose-riding event, which was moved to Otter Rock due to poor conditions at Agate Beach. Surprisingly, ABSC member Marty Skriver beat Corky Carroll in this event. According his brother Jack, "Marty amassed lots of trophies, but I think this win was the most memorable for Marty and everyone who knew him."

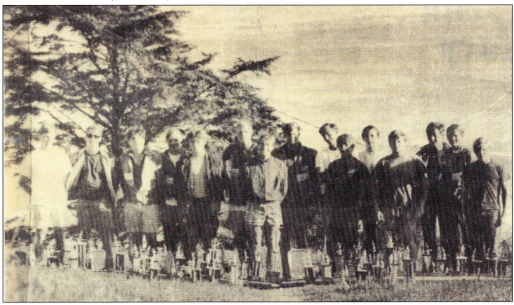

The ABSC members pose with their 70-some-odd trophies just before the 1967 Agate Beach Surf Contest. Shown here are, from left to right, Steve Baley, Tim Allen, Bruce McEntee, Dave Holbrook, Rick Baley, Larry Tucker, David Fish, Paul Kafoury, Scott Blackman, Jeff Hollen, Marty Skriver, Jim Tucker, Marion Bowers, Bill Waterman, and Jerry Holbrook. From 1965 to 1968, the club was thought to be the most active, longest-running group in the Northwest.

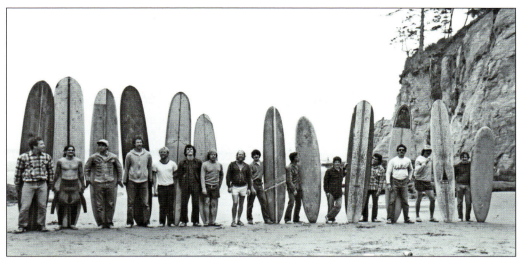

Held at Otter Rock starting in 1981, the Cowabunga Longboard Classic began as a friendly potluck and competition among friends. Seen at this small gathering are, from left to right, unidentified, Martin Hass, Jordan Greenbaum, Joe Widen, Chuck Swanson, Ethan Wilson, Charley Corson, Steve Bagley, Bob McDonald, unidentified, Tony Franciscone, John Benson, Mitch Allara, Stan Hart, and David Burke. (Courtesy of Patti Hart.)

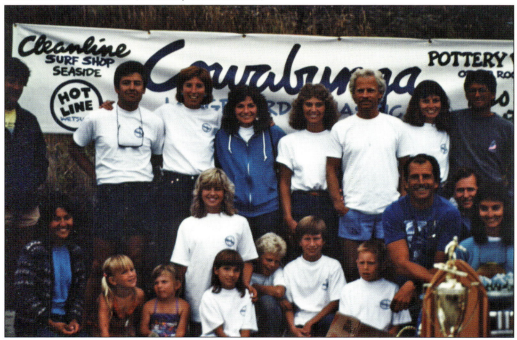

Stan and Patti Hart, along with Mike and Genese Mullin, organized the Cowabunga Longboard Classic, which was run by a group of volunteers. From left to right are (first row) Dianne Rugga, Jeni Hagstrom, Hayley Boston, Beth Mullin, Jenny Bowden, Jeff Mullin, Justin Bowden, Cooper Boston, Stan Hart, John Muller, and Julie Muller; (second row) Larry Bowden, Buck Boston, Sioux Boston, Arlene Bowden, Genese Mullin, Mike Mullin, Patti Hart, and David Guerena. (Courtesy of Stan Hart.)

ABSC member Perry Shoemake is seen holding his third-place trophy, made by David Guerena, at the 1985 Cowabunga Longboard Classic. "The cold water and harsh winter weather were a blessing in disguise," Shoemake recalls. "I never really planned my life; it just happened. Surfing has always been very important to me; it is like my religion."

A group of friends who surfed together during the 1960s and 1970s gathered for a reunion photograph at the Cowabunga Longboard Classic in 1985: (from left to right) Jon Holbrook, Tim Holbrook, Steve Skriver, Jack Skriver, Jeff Hollen, David Fish, Stan Hart, Mike Mullin, Eddie Beers, John Muller, Tim Mack, Jay Nichols, Perry Shoemake, and Scott Blackman (kneeling).

As an art teacher with the local school, co-organizer Mike Mullin created this design for the Cowabunga Longboard Classic poster and T-shirts in 1986. After a couple of years, Mullin, who started surfing in the 1960s, began designing yearly posters, but this image always remained one of his favorites over the 10 years of the contest. (Poster by Mike Mullin.)

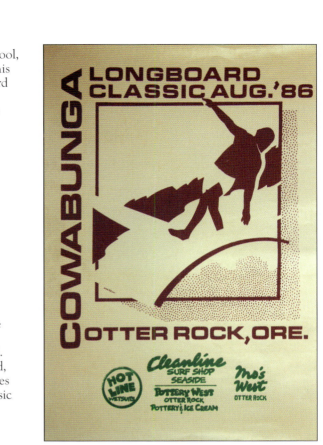

These 1988 Cowabunga Longboard Classic winners' trophies are small replicas of Forbes Mack's red-and-white 1930s paddleboard on which they sit. Mack had donated his large paddleboard to contest organizers Stan Hart and Mike Mullin in 1984. Audrey Guerena recalls that her dad, David Guerena, made all the trophies for the Cowabunga Longboard Classic contests starting in 1985, as he had moved to the beach in the 1970s to surf and build wooden sailboats.

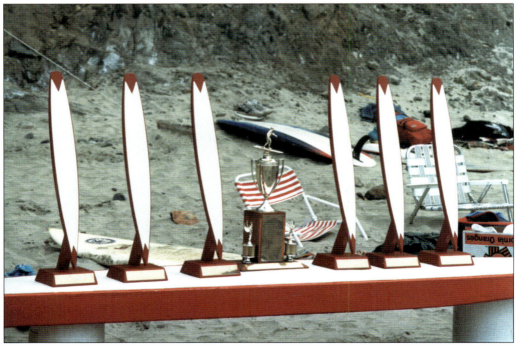

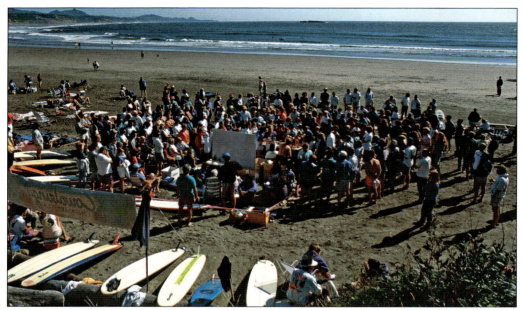

The 1991 Cowabunga Longboard Classic in Otter Rock was the 10th anniversary of the contest, as well as its last. By this time, the event had grown to the point where it took organizers—the Harts and the Mullins—all summer to plan, and with the expansion of the contest came new obstacles, such as permit requirements and insurance fees, which made it impossible for the event to continue.

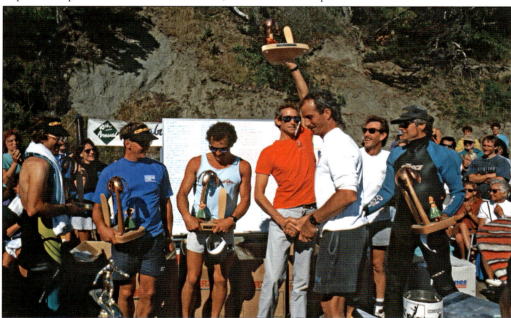

In this photograph from the 1991 Cowabunga Longboard Classic, first-place winner Charles Carse proudly holds up his trophy high above his head. Winners receiving trophies are, from left to right, Brian Wichner, Steve Skriver, Jack Skriver, Charles Carse, Stan Hart (shaking Charles's hand), Tony Stein, and Michael Noack. As seen here, there was a good turnout for the last year of the Cowabunga Longboard Classic.

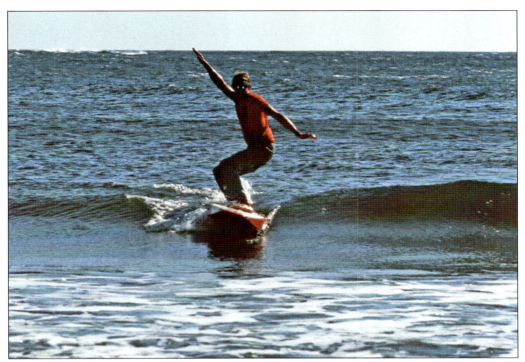

Charles Carse placed first at two contests, in 1984 and 1991. Here, Carse is riding the Forbes Mack paddleboard in 1991. According to co-organizer Mike Mullin, "The tradition at Cowabunga was for the winner to take it out and ride it at the close of the contest." This was no easy task since the board was rudderless and over 12 feet tall.

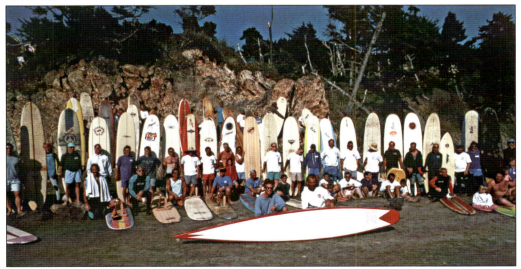

This is the final group photograph of the Cowabunga Longboard Classic, taken at Otter Rock in 1991. The contest represented the shared desire of surfers to gather together for fellowship and competition, and despite this common thread, there was a gap of about a decade when there were no surf contests until Rogue Brewery began sponsoring the Gathering Longboard Classic in 2003.

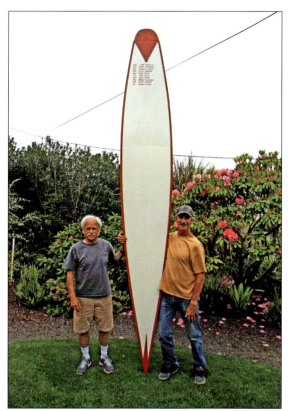

Cowabunga Longboard Classic organizers Mike Mullin (left) and Stan Hart (right), who have surfed the central Oregon coast for decades, are shown here in July 2013. They hold up a symbol of surfing's distant past, Forbes Mack's 1930s paddleboard. All 10 years of past Cowabunga winners' names are painted at the top: Jay Nicholas, Perry Shoemake, Charles Carse, Steve Skriver, Tony Stein, and Brian Wichner, several having won more than once.

According to Jason Garding, "In the mid- to late 1980s, there were a bunch of bodyboarding contests put on by the local BZ Bodyboards sales rep [lying on the ground]. Poncho Sullivan [far right, no shirt] showed up out of nowhere for the contest held at Gleneden State Park, circa 1988." At the time, Poncho Sullivan was a big-name surfer. (Courtesy of Denise Roll.)

Tony Gile organized the Nelscott Surfing Classic in Lincoln City for two years. Pictured here at the 1990 contest, from left to right are Tony Gile with longboard winners Francis Decambra, John Forse, Stan Michaelson, Brian Wichner, and Bo Douglas. Shortboard winners were Brian Wichner, Irwin Landberg, Mike Jipp, Mark MacDonald, Tony Gile, and Dale Inskeep and bodyboard winners Jason Garding and Conan Raines. (Courtesy of Safari Town Surf Shop.)

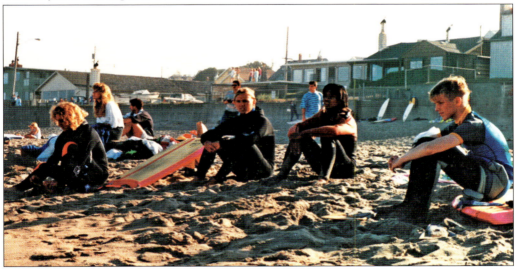

These are contestants who participated in the surf contest sponsored by Liquid Sunshine Surf Shop and owner Shannon Morrow in Nelscott Beach around 1992. From left to right are Shayne Methvin, Jason Garding, Jonathan Mina, and Jake Ellingson. According to Jason Garding, "Jake's parents still own the Sandcastle Motel nearby. There were shortboard, longboard, and bodyboard divisions at the contest. Mar Lehrman from Newport made some sweet ceramic trophies for the contest." (Courtesy of Denise Roll.)

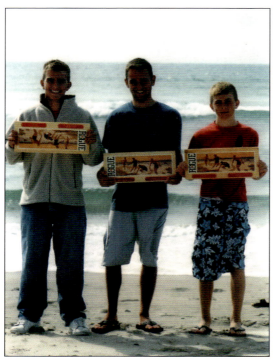

Each September from 2003 to 2011, Rogue Brewery sponsored the Gathering Longboard Classic. From left to right, Jordan Hollen, Mike Boyer, and Kaylor Hollen were the winners of the 2004 Gathering Longboard Classic in South Beach. The Hollen brothers—Jordan and Kaylor—taught their friend Mike Boyer to surf only the year before. They competed against each other in the Gremmie Division, and Kaylor Hollen placed first. (Photograph by Julie Hollen.)

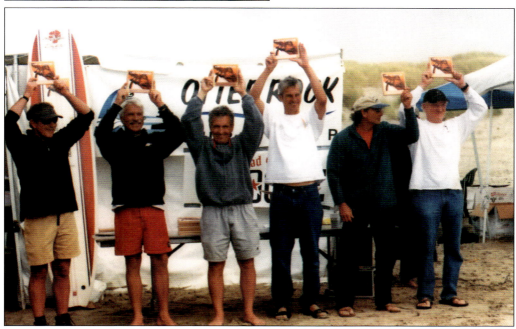

Winners of a men's bracket at the 2004 Gathering Longboard Classic in South Beach are, from left to right, Tony Stein, Otter Rock; Gary Smithers, Coos Bay; Mike Harrington, Agate Beach; Paul La Mont, Newport; Bill Boardman, Brookings; and Danny Anderson, Waldport. This was the second year for the Gathering surf contest, jointly organized by Steve Swan and Rogue Brewery's Stacey Maier. (Photograph by Julie Hollen.)

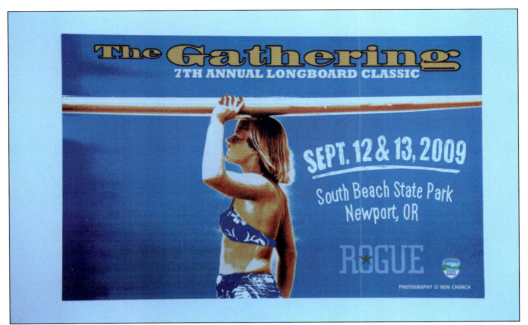

"Surfers can be territorial, representing different tribes or groups," says co-organizer Steve Swan, who oversaw surf contests in California. "By calling the contest the Gathering, it was like bringing all of the surfing tribes together." This is an example of one of the posters advertising the contest. (Courtesy of Rogue Brewery.)

After a nine-year run, September 2011 marked the last of the Gathering surf contests that Rogue Brewery sponsored. Fittingly named for the race of Hawaiian peoples who were very small but very skilled, the Menehunes Division for children ages 12 and under included the following winners: (from left to right) Savannah Russo, second place; Izzy Martinez-Ybor, first place; and Maria Barten, third place. (Courtesy of Rogue Brewery.)

Shown here are the winners of the gals' division (ages 19–29) at the last Gathering Longboard Classic held in South Beach in 2011: (from left to right) Erin Mason, Eva Barten, Becky Mabardy, Haley Richards, and Sarah de Rischebourg. According to Steve Swan, "It was nine wonderful years, but it was time to quit it." (Courtesy of Rogue Brewery.)

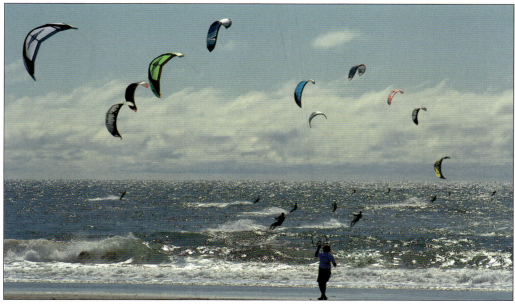

This kiteboarding contest at Roads End in Lincoln City wad held in the spring of 2008. With the help of the Jeff Kafka Surf School from the San Francisco Bay Area, John Forse organized the contest, sponsored by Chinook Winds Casino. Of the 40 contestants who participated, child prodigy Jesse Richman from Hawaii won at only 15 years old. Forse did not do the contest again due to the difficulty in predicting the wind and weather conditions.

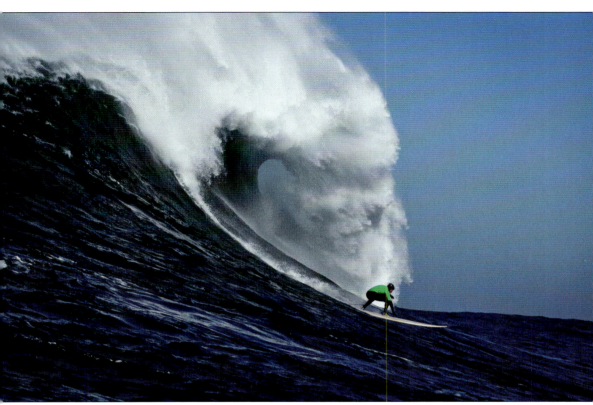

Jamie Sterling placed third in the 2010 Big Wave contest at Nelscott Reef. Photographer Richard Hallman recalls, "My head was buried behind the lens of my water-housing as we weaved in between monster set waves. November 2, 2010, may go down as the biggest waves ever surfed on the Oregon coast. The buoy readings during the day were 23.5 feet at 19 seconds. Jamie glides down a beautiful A-frame here, making the wicked difficult look playfully easy." (Photograph by Richard Hallman.)

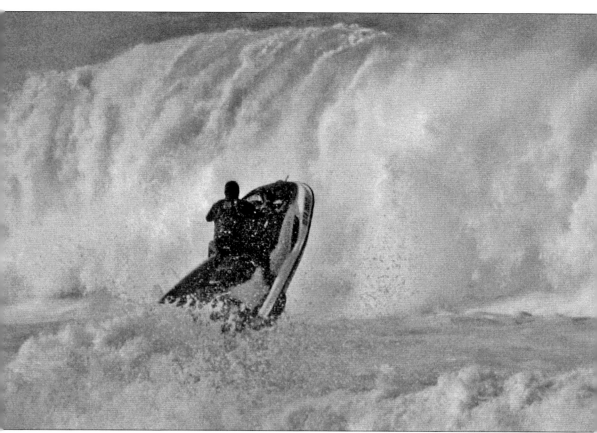

A personal watercraft (PWC) faces serious challenges while trying to reach the reef at the 2010 Nelscott Reef Big Wave Classic. PWCs are responsible for allowing Oregon's large offshore waves to be surfed. John Forse began sponsoring the Nelscott Reef Big Wave Classic in Lincoln City in 2005, featuring surfers from around the world. The surfers ride sizeable waves that break a half mile offshore at Tackle Buster and South Reef.

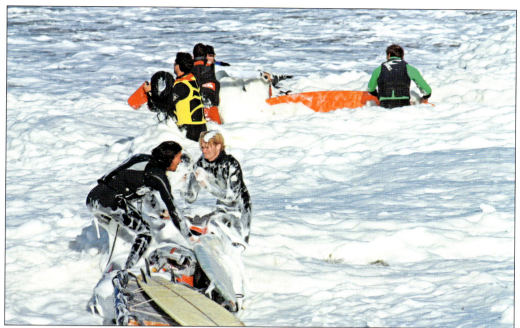

With 40- to 60-foot waves breaking on Tackle Buster Reef, there were periods of mayhem at high tide during the 2010 Nelscott Reef Big Wave Classic. Even though all the contestants and their drivers were some of the most experienced big wave riders in the world, that did not spare them from being hammered by incoming waves. This photograph shows the teams, covered in foam, struggling to launch from the beach.

By mid-afternoon, the tide had dropped, clearing the beach for the 2010 Nelscott Reef Big Wave Classic. Santa Cruz surfer Nic Lamb patiently waits on the beach for his ride to the reef. He would soon face the powerful ocean and experience the difficulty of reaching the outside reef. The largest waves ever ridden in Oregon came rolling in during this contest, with many surfers reporting chaotic conditions on the reef.

Eight-year-old Marley Snavely is seen here at the Otter Rock-n-Roll Surf Contest in June 2013. Snavely is a snowboarder and skateboarder from Bend. Her parents, Kevin Snavely and Shawna Aaland, are not surfers but are proud of Marley for placing in the surf contest even though this was only her third time surfing. Since 2009, Newport's chapter of the Surfrider Foundation has sponsored the children's Otter Rock-n-Roll Surf Contest in celebration of International Surfing Day.

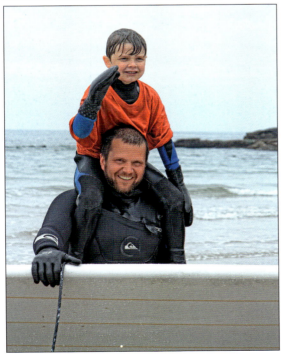

Here is a photograph of Chris Estoos and his six-year-old son, Ivan, at the Otter Rock-n-Roll children's contest in June 2013. Chris started surfing in the Astoria area around 1997. Ivan started surfing with Chris when he was only three years old: "I usually put Ivan on my shoulders and wade out to water up to my neck. I put Ivan on the board and push him along when the waves come."

# Three

# MODERN SURFING

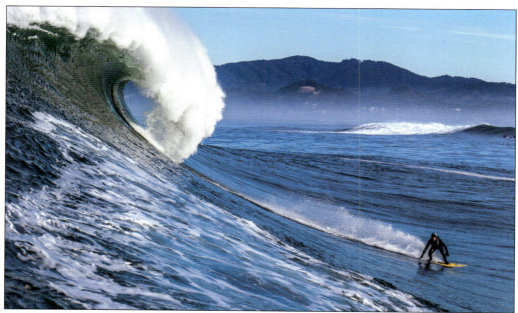

Technically, modern surfing arrived in Oregon in 1964. With advancements in equipment, including wet suits and boards paired with modern technology, surfing continued to evolve. As surfing began to appeal to the masses, both genders and new innovations brought about the development of windsurfing, kiteboarding, stand-up paddleboarding, and big wave surfing. This chapter will look at all those changes, starting in the 1990s up to present day. Seen here in 2013 is Ollie Richardson surfing South Reef in Lincoln City. According to Richardson, "It only takes one wave to change the rest of your life." Ollie lives for big days like this and has enjoyed teaching his dad, Spike, and brother, Larz, how to tow-in surf. Richardson continues to push the limits of surfing in the Pacific Northwest while enjoying it with his closest friends and family.

Based on the surfing movie *Big Wednesday*, some of the Agate Beach neighborhood surfers started the Bear Club in early 1991. Mostly a social club, they sponsored an annual surfing and bonfire party at Agate Beach cove every June for nearly 20 years. From left to right are (first row) Bruce McEntee, Steve Skriver, Bob Hollen, and Tim Holbrook; (second row) Jim Smith and Jack Skriver. (Photograph by Terri Jernigan.)

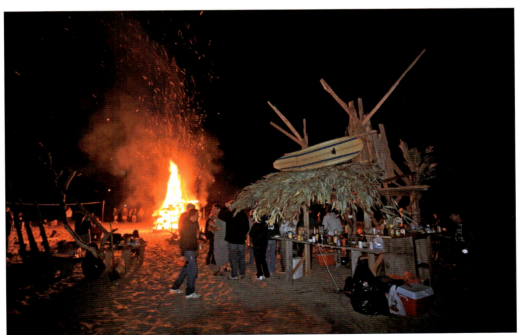

Complete with an open bar and large bonfire, the Bear Club parties could be raucous affairs by nightfall. Jack Skriver recalls, "Our main focus was the annual beach party. We ran electricity under the sand and packed down an enormous stereo system; you could hear the music halfway to Newport. Jim Smith was our pyro-technician, building an enormous pallet pyramid for the night's bonfire."

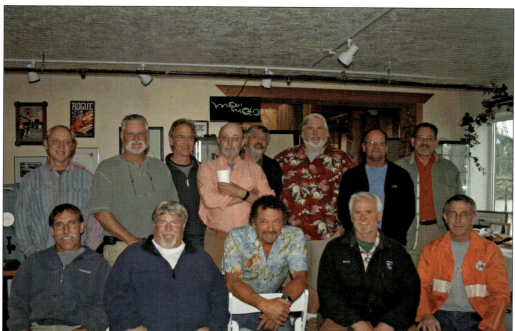

Seen here in June 2007 celebrating Scott Blackman's 70th birthday and the first major ABSC members reunion are, from left to right, (first row) Bob Hollen, Jim Tucker, Jack Skriver, Perry Shoemake, and Jeff Hollen; (second row) Jon Holbrook, Paul Kafoury, Jeff Ouderkirk, Scott Blackman, Bruce McEntee, Larry Tucker, Bill Waterman, and Steve Hall. (Photograph by Sandy Blackman.)

Past ABSC president Jeff Hollen wears his 50-year-old jacket to Scott Blackman's 70th birthday party. The jackets, which were windbreakers, identified all club members in school, around town, and at surf contests. They were considered a status symbol and "chick magnet" in the 1960s. They were purchased from Canvas by Katin, and Scott Blackman designed the felt patch, which was made in Corvallis, Oregon. (Photograph by Jeff Ouderkirk.)

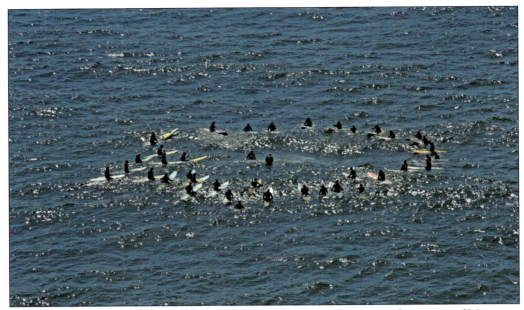

This is a somber image of Marty Skriver's paddle-out ceremony at Agate Beach in August 2008. The death of Marty Skriver, an ABSC member, shocked the surfing community. Skriver, who was well liked, had been considered one of the best all-around surfers from Agate Beach. Conducted in the cove, the ceremony was organized by his brothers Jack and Steve Skriver, who are seen in the middle, surrounded by 40 surfers.

Salem surfers of the 1960s, Larry Bowden (left) and John Muller (right) attended Marty Skriver's paddle-out ceremony at Agate Beach in August 2008. Many surfers from across the state came to show their support, as they had surfed with Marty over the years or competed against him in surf contests of the 1960s. Larry Bowden, along with Garth Gilmour, was featured in the *Statesman Journal* on August 14, 1965, for Salem youth surfing the Oregon coast.

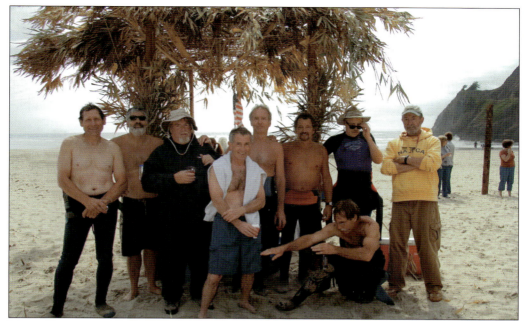

Marty Skriver's paddle-out ceremony brought many surfing buddies to Agate Beach, including original ABSC members and former Agate Beach neighborhood guys who were too young to join the club back in the 1960s. From left to right are Marion Bowers, Bruce McEntee, Jim Tucker, Jeff Hollen, Jeff Ouderkirk, Jack Skriver, Tim Holbrook, Scott Blackman, and Bob Hollen (front). (Photograph by Sandy Blackman.)

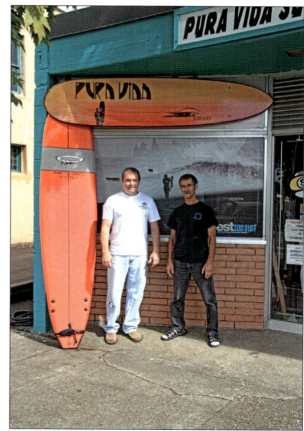

Together, Robert Rube (left) and Al Krieger (right) jointly own the Pura Vida Surf Shop in Philomath. Situated 50 miles inland from the ocean, the shop caters to surfers who live in the valley. Among the boards on display is Fred Flesher's 1945 paddleboard, which provides a look at the early days of Oregon surfing.

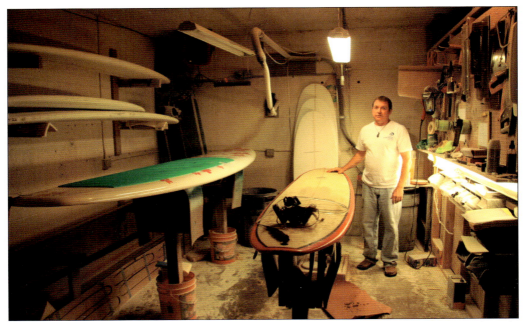

In the rear of Philomath's Pura Vida Surf Shop, co-owner Robert Rube builds and repairs surfboards. Rube was a military brat who spent 15 years of his life growing up on bases, including in Hawaii. "I learned to surf on Oahu and paid $15 for my first board," Rube recalls. "That was the beginning for me, and I've been involved with surfing in one way or another ever since."

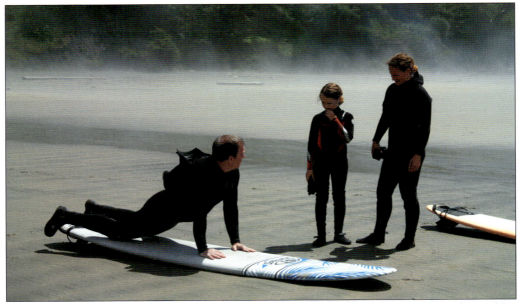

The co-owner of Pura Vida Surf Shop, Robert Rube, gives surfing lessons to Max Ocho and his mother, Felicite Geiger, at Otter Rock in 2013. Here, Rube is demonstrating how to stand up on the board. They practiced techniques, concentrating on balance and their stance before entering the water. Today's novice surfers can rent any type of equipment and receive lessons on how to surf. Otter Rock is a good beach for beginners.

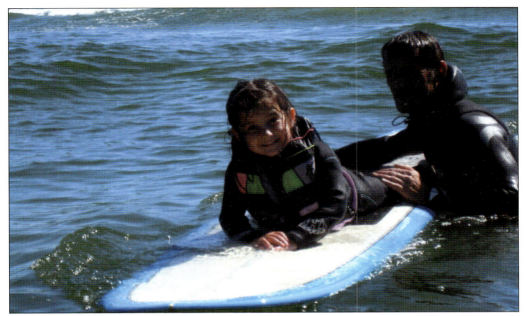

Al Krieger, co-owner of Philomath's Pura Vida Surf Shop, is a resident of Otter Rock. Seen here in 2007, he teaches one of his granddaughters, Maia Krieger, age five, how to surf. Back in the mid-1960s, when he was in high school, Krieger learned to surf around Pacific City. He attended community college in Coos Bay, where he helped to start the Kahuna Surf Club. (Photograph by Rachel Krieger.)

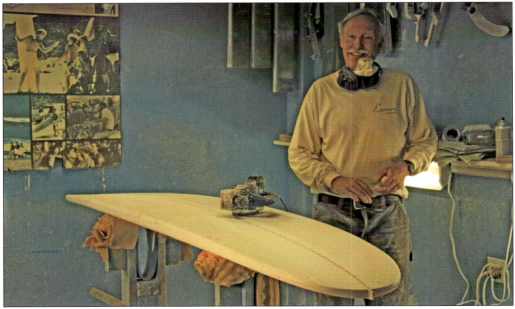

Board shaper and owner of Envision Surfboards Ralph Meier has been surfing since he was an adolescent in Southern California. After moving to Oregon and becoming a teacher, he passed his interest on to his wife and daughters. When he later retired from teaching, Meier became serious about making surfboards. His shop can be found five miles east of Newport, up a rural country road on acreage in the forest.

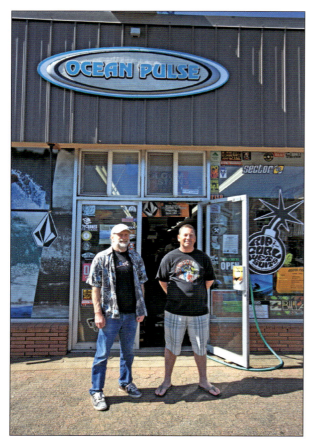

Tom McNamara (left) and Greg Niles (right) co-own Ocean Pulse Surf Shop in downtown Newport on Highway 101. McNamara opened the shop in 1991, and Niles became a partner in 1996. McNamara and Niles, who met through surfing, both believe that, today, there are fewer skilled surfers in comparison to the number of intermediate surfers. "Surfing was more fun when it was on the fringe. Now it's more mainstream today," recalls McNamara.

This is a shot of Tom McNamara surfing at South Beach in November 2005 near Blue Pole, about 300 yards south of the jetty. In 1972, McNamara migrated from New Jersey after reading an article about surfing in Oregon. He started making boards when he lived in Siletz, eventually opening up a surf shop in Newport. (Photograph by Chris Speakman.)

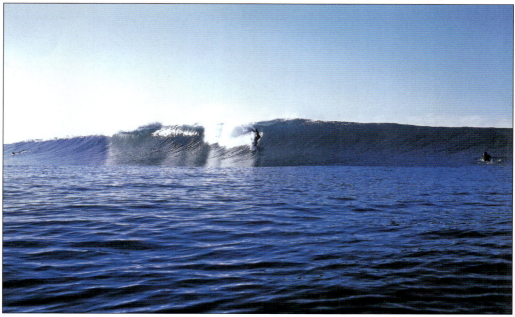

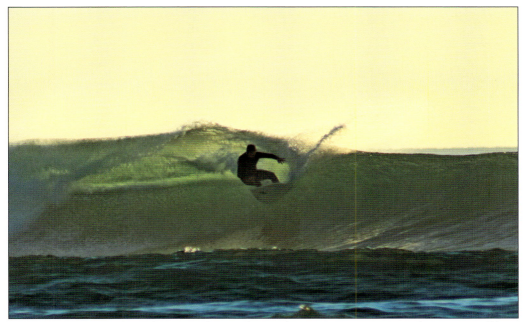

Greg Niles is seen working the waves close to the South Jetty in January 2009. The evening offshore highlights Ocean Pulse Surf Shop co-owner Greg Niles, with his recognizable Northwest "shaka" hand signal, while surfing off the lip of the wave. Strong easterly winds hold up these waves to produce an exciting and natural phenomenon: hot waves in cold water.

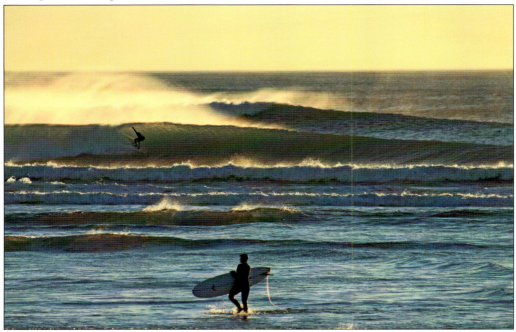

Two unidentified surfers are seen in January 2009 surfing the South Jetty at its very best. At times during the winter, conditions will line up just right when the swell and the sandbars cooperate. When the weather clears, the jetty can produce waves of this caliber.

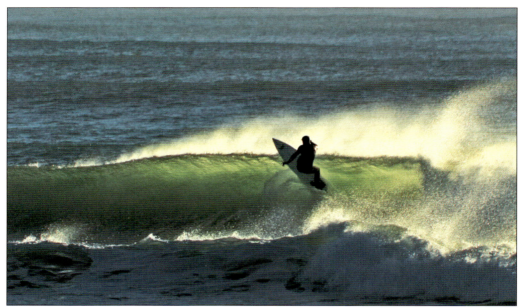

With the use of modern technology, surfers have access to surf predictions days ahead of time. When the day arrives, surfers flock to places like the South Jetty in hopes of catching conditions like these. This unidentified surfer saw the swell coming and took advantage of it. At the end of the day, he will be taking home a nice memory of this off-the-lip move.

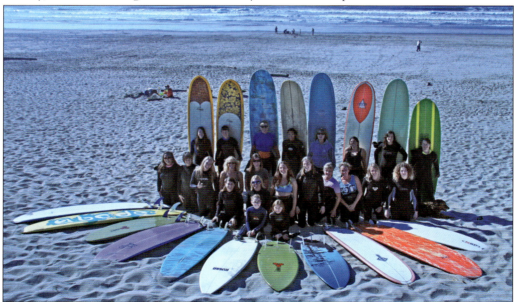

Female surfers gather at South Beach in October 2012. From left to right are (first row) Olivia Pappalardo and Sophia Pappalardo; (second row) Kath Proctor and Allison Tice; (third row) Ruth Meier, Barb Wright, Chanteal Khalsa, Shelly Heim, Meira Cole, Olivia Schroeder, Serina Adams, Corrina Hargett, Katey Townsend, Tricia Quick, and Hailey Morris; (fourth row) Malia Moore, Pam Moore, Danielle Emerick, Lisa Shearer, Jody George, Breeze Powell, Yasmina Dedijer-Small, and Lisa Field.

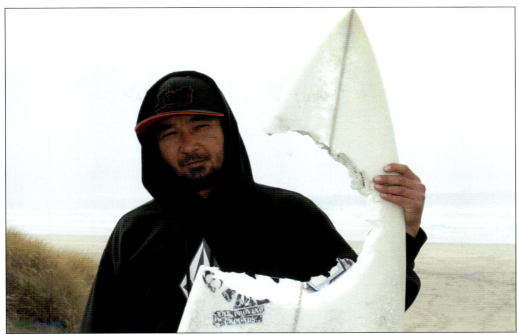

Newport surfer Bobby Gumm survived a shark attack at South Beach on October 21, 2011. "I saw the water churning up like there were piranhas," his friend Ron Clifford recalls. "The shark pushed Bobby 10 feet out of the water like a geyser." The shark also took a 23-inch chunk out of Gumm's board. Although shark attacks are rare, they do still happen. Gumm believes, "The man above kept me alive." (Photograph by Michelle Harris.)

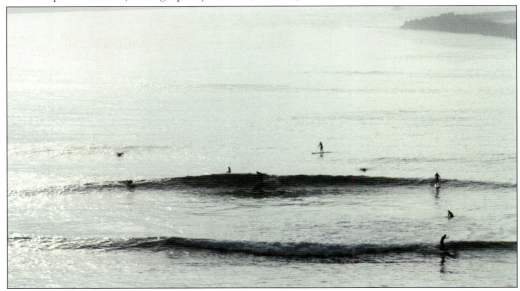

When the surf in the Newport area is too big, Happy's becomes rideable under certain conditions. Large swells push up the Yaquina River channel, make a left turn at the elbow of the North Jetty, and roll across the reef-like bottom. The slow-moving waves are seldom over four feet, but during the winter, with long spells of unridable waves, this spot can be a last resort.

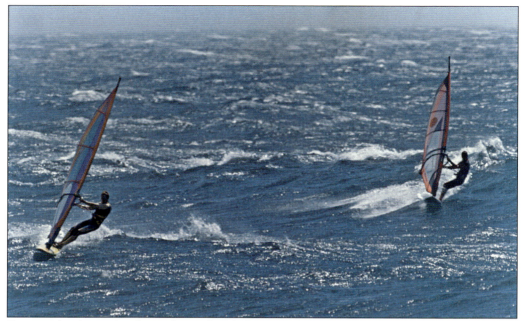

Seen windsurfing at South Beach is Mike Jakobsson on the left. After windsurfing in the 1980s and 1990s, Jakobsson transitioned to kiteboarding because, in addition to requiring less equipment, it was easier to learn and less jarring on the body, particularly the elbows. Jakobsson remarks that he is just as enthusiastic about kiteboarding as he once was about windsurfing. (Courtesy of Mike Jakobsson.)

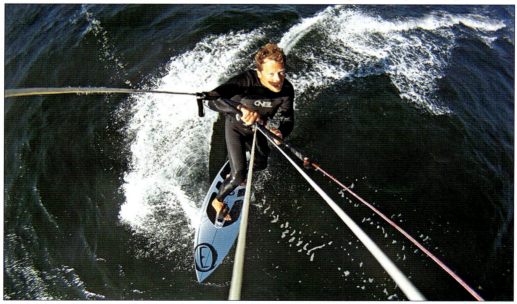

Mike Jakobsson is seen kiteboarding at Beverly Beach in 2013. Jakobsson and his wife, Heidi, moved from California in 1993 and settled in Newport, where Mike is currently one of six teachers at Newport High School who are avid surfers. Jakobsson believes surfing is a lifestyle: "It's how you live, where you choose to live and travel." A camera attached to Jakobsson's equipment gives us a different perspective of kiteboarding. (Photograph by Mike Jakobsson.)

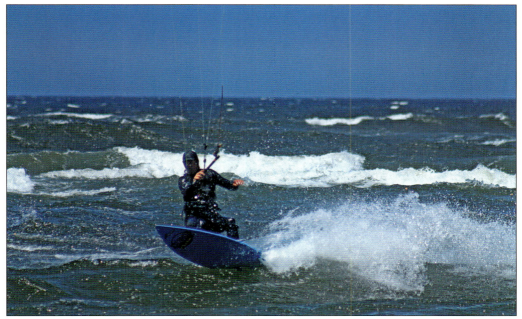

Here, Newport surfer Steve Britt kiteboards at Ocean Beach, south of Yachats, in July 2013. Britt recalls, "I saw a surfer on TV's *Wide World of Sports* when I was six and decided I would be a surfer." Britt moved from Salem after high school in 1985 and became a commercial fisherman for many years so he could surf. Britt gives kiteboarding lessons in his spare time.

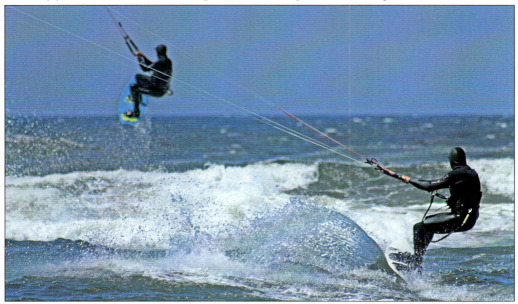

With Mike Jakobsson in the foreground, Steve Britt is seen jumping a wave in July 2013. Because there was no wind at South Beach, Britt and Jakobsson headed south to a windy spot at Ocean Beach. "I really like surfing waves," Jakobsson says, "whether paddling into them or using a kite to pick them up." Also an avid surfer, Britt remembers, "When I moved here, I was influenced by the early local surfers—the Skrivers, Holbrooks, and Perry Shoemake."

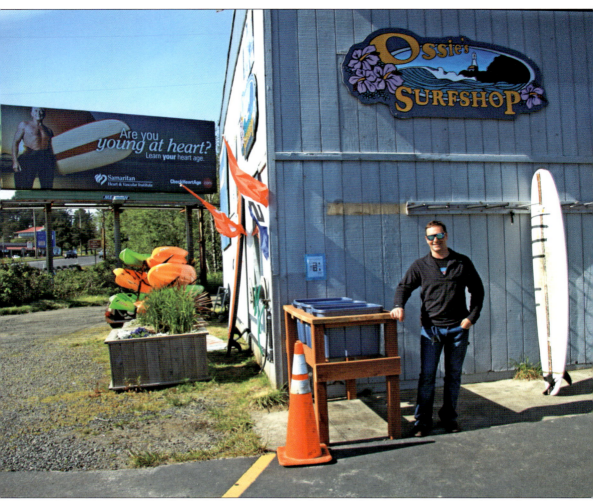

While growing up in landlocked Ohio, Daniel Hasselschwert always wanted to surf. After graduating from college with a teaching degree, he arrived in Oregon at the age of 22 and became the owner of Ossie's Surf Shop in Agate Beach. He taught and developed a surf club for kids at Waldport Middle School until his surf shop became successful. He has taught private surf lessons, and for 10 years, his shop has offered college credits to Oregon State University students.

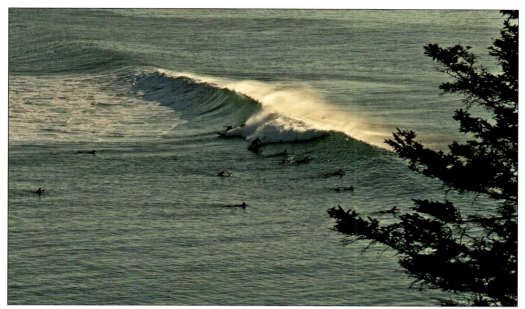

Seen here in 2009, this spot at Agate Beach is known as Avalanche. With its big channel and easy access, Avalanche can get crowded on smaller days. When Avalanche gets big, it really thins out the crowd. "Avalanche was named by me, Steve, and other neighborhood kids when we were young and would push giant boulders into the water from Quarry Cove," Jack Skriver recalls. "We caused mini avalanches—that's how it got its name."

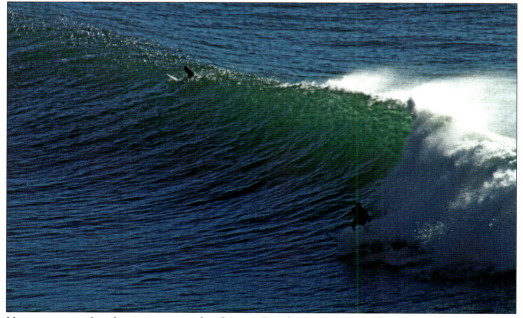

Here, a group of surfers is seen outside of Agate Beach in 2008. Jack Skriver recalls, "Avalanche really came alive in the winter of 1999–2000 providing the best waves I've ever seen, by far, at Agate Beach. I still get excited thinking of that year." Many of the local surfers refer to Avalanche using the nickname " 'Lanches."

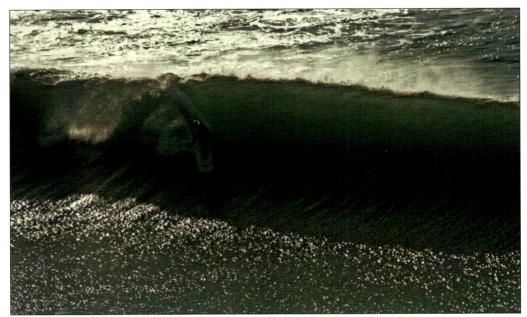

According to Jack Skriver, "This is the inside section of Avalanche [in 2008]. It would keep on breaking until you or the wave would practically run into the cliff. It's a whole other part of the wave. One year, the sandbar got so dangerous that we called it Kvorkian's because it was so suicidal to ride."

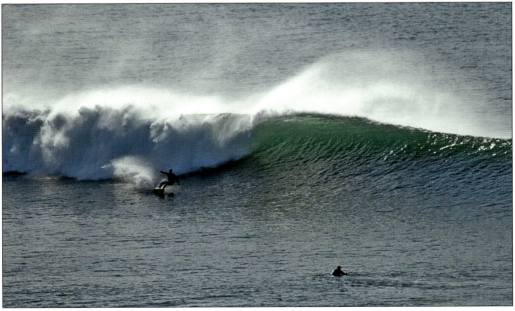

Jack Skriver is seen surfing Agate's classic 'Lanches left. Bright, sunny, east-wind days were a welcome relief in mid-winter. As Jack recalls, "Avalanche sometimes had a ferocious rip next to the rocks and in the channel. The easy access off the rocks would put unknowing surfers in peril. There were many rescues and broken and lost boards on big days. There was even one fatality, as reported in the *News Times*." (Photograph by Andrew Ross.)

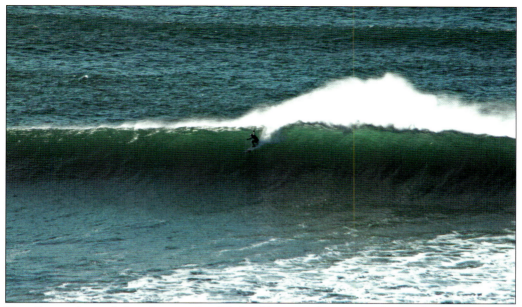

Tony Stein, who took this photograph of Taylor Olson on a big wave at Avalanche, recalls, "I shot the picture a couple of years ago on a big, blustery December 2011 offshore day, and Taylor was the only taker! He is a very patient and fearless surfer who waited for this beauty. He definitely got hung up on the top of the wave with the howling offshores but managed to drop in and make the wave!" (Photograph by Tony Stein.)

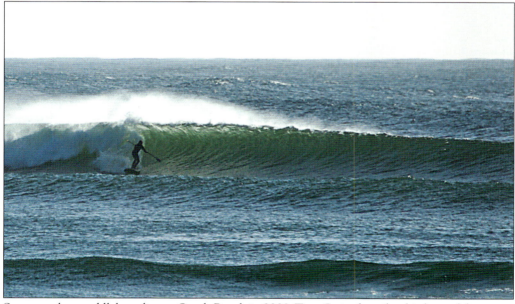

Seen stand-up paddleboarding at South Beach in 2009, Tony Stein describes his love of the water: "Surfing provides such an incredible connection to the sea. I have been surfing for over 53 years, and I still get the same feeling of excitement as I did on that first wave I ever rode. To me, surfing is riding floating crafts that harnesses the energy of the sea: surf mats, boogie boards, surfboards, sailboards, stand-up paddleboards, and kayaks." (Photograph by Andrew Ross.)

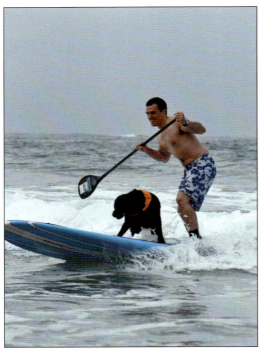

Ollie Richardson and his dog Bella are shown stand-up paddleboarding together. As Richardson recalls, "Bella started surfing with me six years ago, when she was one year old. Bella runs up to me and jumps on the board. She's so excited, and so I pushed her out into a white-water wave. She rode it for about 10 feet. The rest is history." Bella has been riding waves ever since. (Courtesy of Dave Price, *Oregon Coast Today*.)

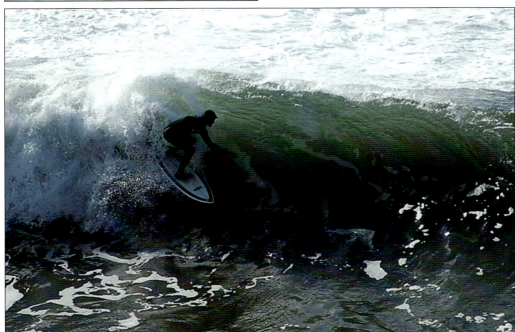

Kirk Tice remembers that this photograph of him surfing at Agate Beach in January 2007 was taken "during an epic swell, when Agate was good as I have ever seen." Now a teacher at Newport High School, Tice was once a professional surfer who surfed around the world and beat Kelly Slater twice in competitions. According to fellow teacher Mike Jakobsson, "Kirk is one of the best shortboarders in the Pacific Northwest." (Photograph by Andrew Ross.)

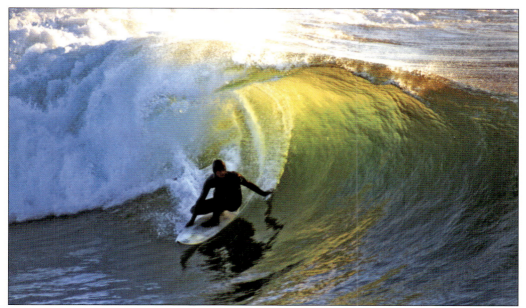

Here is P.J. Collson at Agate Beach in 2007. Now a teacher at Newport High School, Collson started surfing when he was a college student. As P.J. recalls, "I always did water sports—water skiing, water rafting, snorkeling. But when I was a student at OSU, I would store my surfboard at my grandpa Pete's house in Newport. I like the combination of nature, exercise, and the mental place that surfing puts you." (Photograph by Marney Starkey, Doublevizion.)

Mike Jipp opened the Lincoln City Surf Shop in 1997. Over the years, Jipp has become an avid collector of surfing memorabilia, preserving the Northwest history. His Pacific Northwest Surfing Museum is currently housed inside his Lincoln City Surf Shop, but Jipp hopes to eventually find a permanent location for the museum's sizable collection.

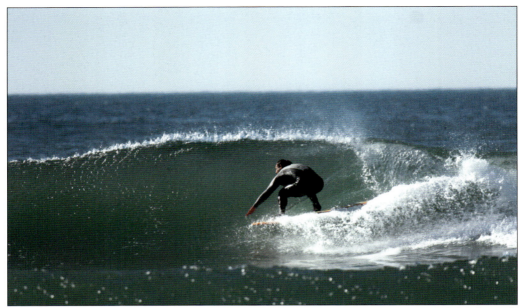

Mike Jipp, owner of the Lincoln City Surf Shop, navigates a steep section at Roads End, north of Lincoln City, around 2008. The morning's light easterly winds have helped to shape the small wave. Jipp began surfing the central Oregon coast with his friend Tony Gile when they were students at Cascade Union High School in Turner, Oregon. (Courtesy of Mike Jipp, Pacific Northwest Surfing Museum.)

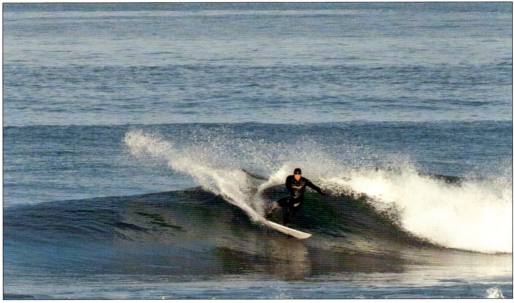

Here is Lincoln City surfer Jason Garding at Nelscott Beach in 2013. Garding began surfing in Lincoln City in 1985, when he was old enough to buy a wet suit, and has been surfing ever since. "I quickly learned being a surfer in Oregon was something special," Garding says. "On my first trip to the North Shore, Hawaii, I realized that our home surf was just as powerful and even more violent than the North Shore." (Photograph by Mattie Starr.)

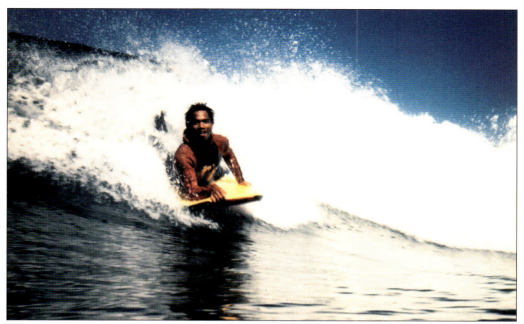

Jonathan Mina, a friend of Jason Garding, is shown bodyboarding at Nelscott Beach in 1985. Raised in Molokai, Hawaii, Jonathan lived with his uncle Charlie Mina while attending college in Oregon. Charlie was a local physical therapist and a regular bodyboarder in the lineups around Lincoln City. (Photograph by Jason Garding.)

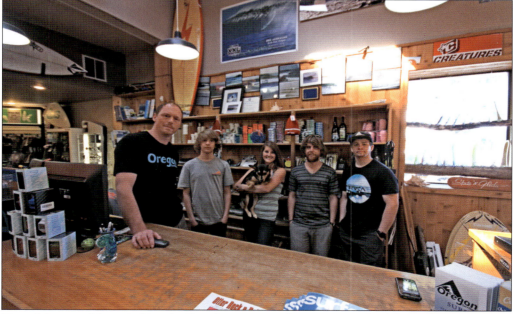

One of three surf shops in Lincoln City that caters to the various needs of the surfing community along the central Oregon coast, the Oregon Surf Shop and its crew are pictured here. From left to right are Tim Henton, who has owned the surf shop for eight years; his son, Jesse Henton; Felicia Haun, holding Lola the dog; Mattie Starr; and Tyler Cunningham.

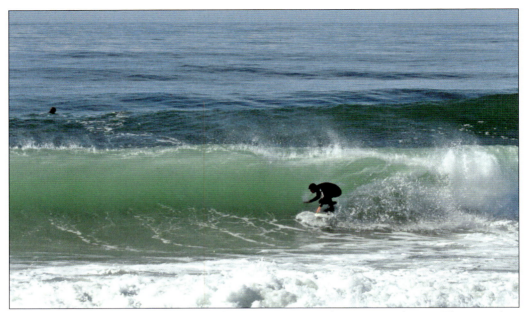

Tim Henton describes this photograph of him surfing in Lincoln City around 2011: "This was taken on a late-September day near our shop. It was warm, sunny, and the waves were amazing—one of those days that, as an Oregon surfer, you grab a hold of when you can because they don't come around all that often." Henton, who grew up in the Eugene-Springfield area, now lives in Neotsu, north of Lincoln City. (Photograph by Felicia Haun.)

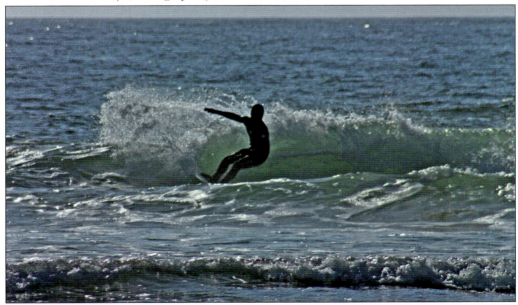

Photographed at Nelscott Beach in May 2013, Mattie Starr started seriously surfing when he was 16 years old around Florence, Oregon. After high school, Starr moved from the valley to the Oregon coast, where he has worked at the Oregon Surf Shop in Lincoln City for four and a half years. As his life revolves around surfing, Starr states, "Everything I do is calculated to get more waves."

Dayl Wood and one of his identical twin sons are pictured at the Otter Rock-n-Roll contest for children in 2009. Wood started surfing in San Diego, California, in eighth grade and has been surfing the Northwest coast for 20 years. In addition to teaching at Newport High School, he has instructed beginner surf lessons for shops in Lincoln City, Newport, and Pacific City. He and his wife, Kelly, live in Gleneden Beach and have five children, all of whom have surfed at one time or another. (Photograph by Kelly Wood.)

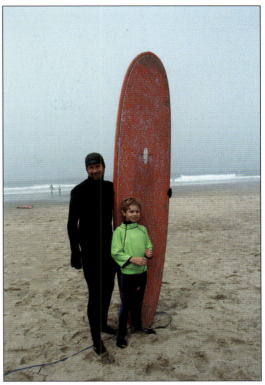

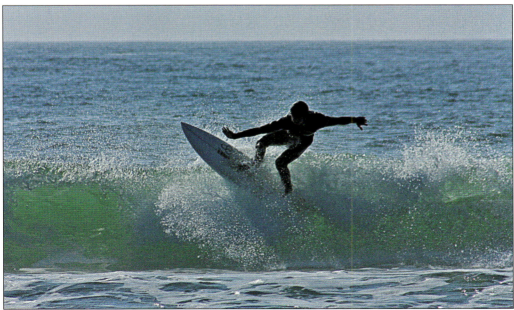

Here, Deklyn Wood is surfing Nelscott Beach in Lincoln City in May 2013. A member of the Newport High School track and cross-country teams, Wood started college in the fall of 2013. Wood and his father, Dayl, also give surf lessons for Safari Town Surf Shop, where Wood is a sponsored team rider. Tony Gile, owner of the shop, describes Wood as a phenomenal athlete and a great kid.

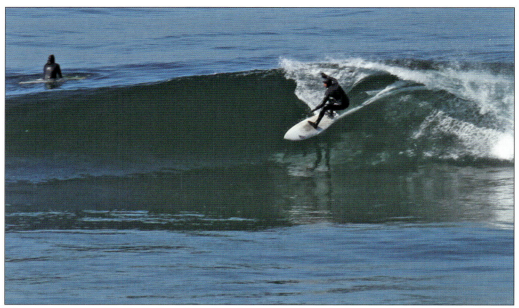

This is an image of Keith Galbraith surfing Canyons in Lincoln City in October 2012. Galbraith began surfing when he lived in Eugene, Oregon: "When I went surfing with my friend along the Oregon coast, it got to me. I was hooked." As Keith believes, "Surfing inspires a search to find perfection in waves and abilities. You can leave the world's troubles at the beach and find a reward for your efforts." (Photograph by Skye Anderson.)

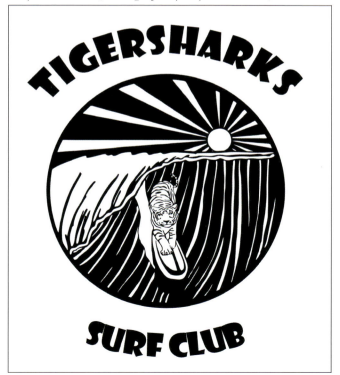

The Tigersharks emblem was inspired by the loss of Taft High School student Joe Furlan. Cofounders Keith Galbraith and Skye Anderson wanted to work with Lincoln City youth to make a difference. Skye states, "The Tigersharks Surf Club was founded in the summer of 2012 with a goal of educating youth about living a positive and healthy lifestyle through the means of safely surfing and understanding their local ocean to have fun!" (Emblem design by Noah Lambie and Brian Freschi.)

Seen here in Lincoln City in 2013, Tony Gile reminisces his first encounter with surfing: "I was around seven, fishing from the pier with my grandfather, when I saw a surfer sliding down the face of a wave, and thought, 'That's what I want to do.' " Gile started surfing in 1976, then opened his first surf shop with his brother-in-law, Jack, in Manzanita. In 1987, Gile moved to Lincoln City, where he now owns the Safari Town Surf Shop.

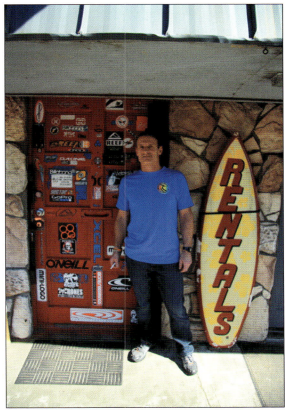

With a GoPro camera attached to the nose of his board, Tony Gile waits for the next wave so he can capture an up-close view of his surfing. Growing up in Stayton, Gile developed a love for the ocean early in life and, as he says, "loved being out in God's creation." Eventually, Gile opened Safari Town Surf Shop in 1987.

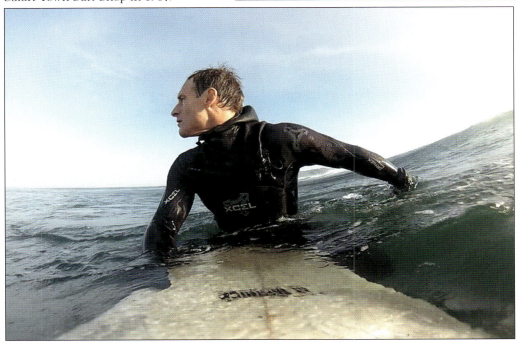

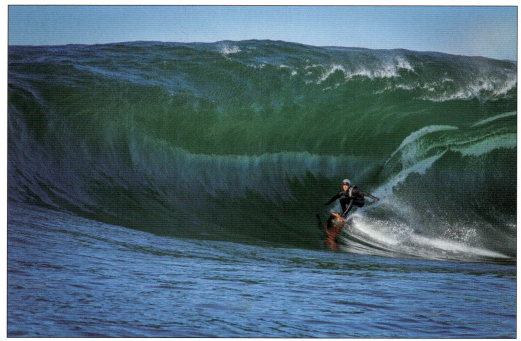

Here is Ollie Richardson surfing Scott's Reef, north of Depoe Bay, in 2009. At age nine, Richardson began surfing with his dad and brother in Coos Bay. "I owe everything to surfing," Richardson says. Starting in 2004, Richardson and his friend Daniel Hasselschwert decided they wanted to ride bigger waves. When they saw Scott's Reef, they said, "There it is; let's go get it." And they did. (Photograph by Richard Hallman.)

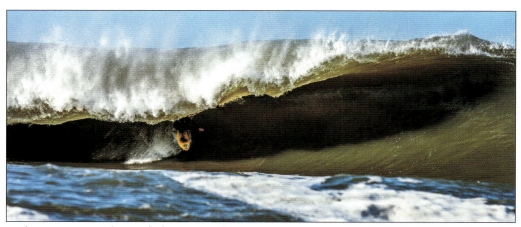

In this image, Daniel Hasselschwert is surfing Scott's Reef in 2009. Hasselschwert, Richardson, and other surfers would look at Scott's Reef and wistfully comment, "If we could only get out there . . . " With the development of personal watercraft and improvements in equipment, that feat is now possible. Hasselschwert is never happier than when he is riding big waves: "I like getting pounded, getting chased. It appeals to me. I like it bigger, bigger, bigger! I say to myself, 'I can do this.' " (Photograph by Richard Hallman.)

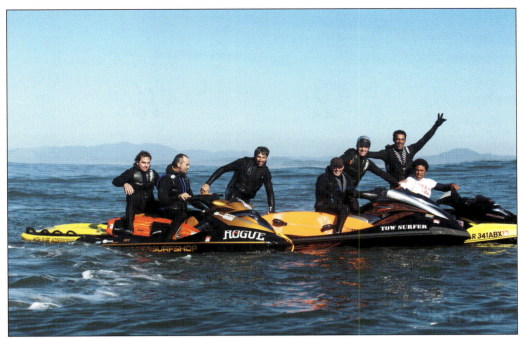

After a gnarly beach launch from Fogarty Creek, this photograph was taken after riding Scott's Reef. The visiting Hawaiian pros showed local surfers how they tow into slab waves. From left to right are Dan Hasselschwert, Ryan Heim, Keith Galbraith, Garrett McNamara, Ollie Richardson, Ikaika Kalama, and Kealii Mamala. McNamara holds the record for riding the biggest wave in the world, and Kalama is the son of legendary surfer Dave Kalama. (Courtesy of Daniel Russo.)

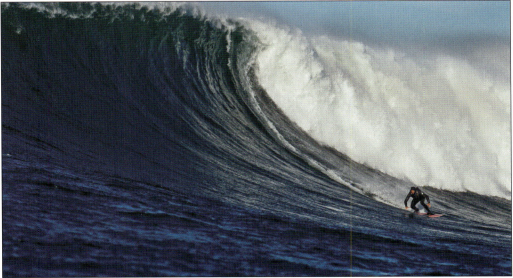

George DeSoto is pictured at Tackle Buster Reef in December 2011. George started surfing at Nye Beach when he was 18 years old. He comments, "I have surfed all over the world but my backyard gave me one of the best, most enjoyable big days of my life. Praise Jesus—can I have another?" (Photo by Richard Hallman, FreelanceImaging.com.)

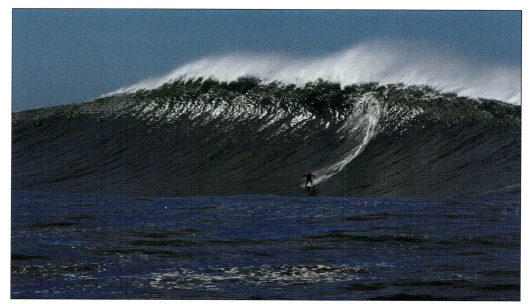

Eric Akiskalian, age 51, was nominated for the Biggest Wave Award in the Billabong XXL Big Wave Awards in 2011 when he rode this massive 65-foot wave on South Reef in Lincoln City. Currently, this is the largest wave ever surfed in the Pacific Northwest region. Eric also founded Towsurfer.com in 2000 and has become an ambassador for the sport of tow-in surfing, which he promotes globally. (Photograph by Richard Hallman)

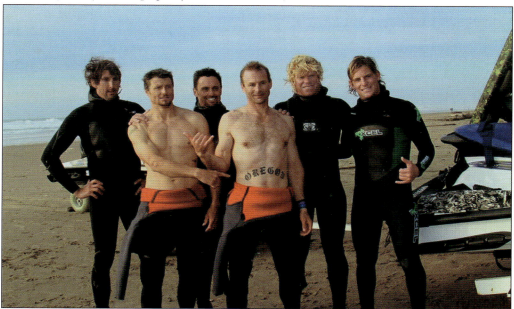

Big wave surfers pose at Canyons in Lincoln City in 2011. From left to right, local surfers Keith Galbraith, George DeSoto, Eric Akiskalian, and Geth Noble had the pleasure of sharing a big wave paddle-in session at Tackle Buster Reef with New York surfers Cliff and Will Skudin. The Skudin brothers are professional surfers with the Big Wave World Tour. Eric recalls "this was an amazing day during a 12'–15' swell." (Photograph by Michelle Harris.)

Ron Houchens, pictured with his board and design, recalls, "I grew up in Idaho but always wanted to live at the coast and surf." Arriving here, he began surfing in 2002 and started painting designs on surfboards, selling them in surf shops and galleries. Ron is busy being a father, attending college to get an art degree, and doing his art, including surf-related art.

Featured at numerous Oregon surf contests, artist Todd Fischer captures the art of surfing in this painting, titled *Happy Hour*. The first time he surfed was with his dad; Fischer remembers, "I was hooked." His parents encouraged him creatively when he was young, which is reflected in his art and how it connects to his passion for surfing: "I've never been expressive in words. I've never been able to describe surfing with words, so I try to capture the way it makes me feel." (Courtesy of Todd Fischer.)

# Discover Thousands of Local History Books Featuring Millions of Vintage Images

Arcadia Publishing, the leading local history publisher in the United States, is committed to making history accessible and meaningful through publishing books that celebrate and preserve the heritage of America's people and places.

Find more books like this at
**www.arcadiapublishing.com**

Search for your hometown history, your old stomping grounds, and even your favorite sports team.

Consistent with our mission to preserve history on a local level, this book was printed in South Carolina on American-made paper and manufactured entirely in the United States. Products carrying the accredited Forest Stewardship Council (FSC) label are printed on 100 percent FSC-certified paper.